Klimt

1862-1918

Grange
BOOKS

Page 6:
Gustav Klimt, Photography

Designed by:
Baseline Co Ltd
19-25 Nguyen Hue
Bitexco Building, Floor 11
District 1, Ho Chi Minh City
Vietnam

ISBN 1-84013-740-1

Published in 2004 by Grange Books
an imprint of Grange Books Plc
The Grange Kingsnorth Industrial Estate
Hoo, nr Rochester, Kent ME3 9ND
www.grangebooks.co.uk

Printed in China by Everbest Printing Co Ltd

Foreword

"As the committee must be aware, a group of artists within the organization has for years been trying to make its artistic views felt. These views culminate in the recognition of the necessity of bringing artistic life in Vienna into more lively contact with the continuing development of art broad, and of putting exhibitions on a purely artistic footing, free from any commercial considerations; of thereby awakening in wider circles a purified, modern view of art; and lastly, including a heightened concern for art in official circles."

Gustav Klimt

Biography

1862: Birth of Gustav Klimt in Baumgarten, near Vienna. His father, Ernest Klimt was a gold engraver and his mother, Anna Finster, was a lyric singer.

1876: He enters the School of Arts and Sciences at the Museum of Art and Industry in Vienna. He takes painting classes from Professor Laufberger.

1877: To make money, he takes photographic portraits.

1883: Klimt gets his degree from The School of Arts and Sciences in Vienna. He opens a workshop with one of his brothers (Ernst Klimt) and another painter (Franz Matsch). They do several works together, some of which are frescos for theatres.

1885: The group decorates the Hermès villa and the National Theatre of Fiume.

1887: The Municipal Consul of Vienna asks Klimt to paint an interior scene of the ancient imperial theatre.

1888: Klimt completes the painting of the imperial theatre. He receives the gold cross of merit for the accomplishment.

1889: Klimt begins the decoration of the staircases at the Museum of Art History in Vienna. He receives the Imperial Prize, awarded for the first time to him.

1890: Klimt becomes a member of the group for artists in the plastic arts in Vienna. With his brother Ernst and Franz Matsch, he is awarded "the highest recognition" for the decoration of the Museum of Art History.

1892: His father and his brother Ernst die.

1893: Klimt takes a trip to Hungary where Duke Esterhazy asks him to paint the Totis theatre.

1894: The Minister of Education asks Klimt and Matsch to do the Faculty Paintings on the ceiling of the hallway in the University of Vienna.

1897: Klimt leaves the association for artists in the plastic arts in Vienna. Joseph Maria Olbrich, Josef Hoffmann and Klimt found the Vienna Secession and Klimt becomes the Succession's president. Olbrich, Hoffman and Klimt work on the paintings *Philosophy* and *Medicine* for the University.

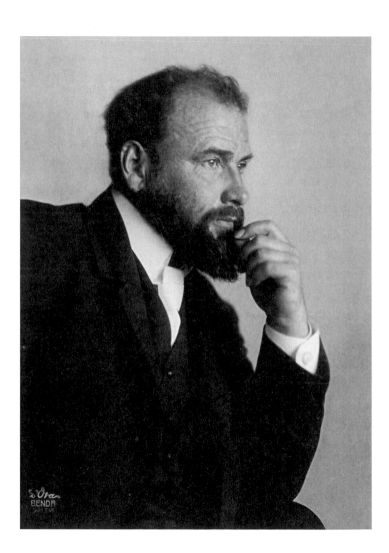

1898: First exposition of the Vienna Secession and the founding of its magazine: *Ver Sacrum*. The same year, Klimt becomes a member of the International Society of Painters, Sculptors and Engravers in London and is nominated a corresponding member of the Munich Succession.

1899: He finishes the decoration for the Music Room at the Dumba palace with his paintings *Schubert at the Piano* and *Music*.

1900: He exhibits, next to landscape paintings, his unfinished *Philosophy*, in the Secession's house and the painting provokes violent protests. However, he receives a gold medal for this painting at the Universal Exposition in Paris.

1901: The exhibition of *Medicine* receives criticism from the press.

1902: The Secession has an exhibition with a presentation of the *Beethoven* frieze.

1903: A collective exhibition at the Secession with eighty works by Klimt. Klimt takes a trip to Ravenne and Florence.

1905: The order for the Faculty Paintings is cancelled and then bought back. Klimt retires from the Secession and leaves for Berlin where he participates in the Alliance of German Artists Exhibition with fifteen paintings and he receives the "Villa Romana" Prize.

1906: Foundation of the Alliance of Austrian Artists (Klimt becomes president of the Alliance in 1912). He becomes an honorary member of the Royal Bavarian Academy of the Decorative Arts in Munich.

1907: He finishes the Faculty Paintings and exhibits them in Vienna and Berlin.

1910: He participates in the Venice Biennial.

1911: Participates, with eight paintings, at the International Exhibition of Art in Rome and receives the first prize for *Death and Life*.

1912: Klimt becomes president of the Alliance of Austrian Artists in Rome.

1917: Klimt becomes an honorary member of the Academy of the Decorative Arts in Vienna after the chair had been refused four times by the minister.

1918: On January 11th, Klimt suffers from a stroke in his Viennese apartment and dies on February 6th, leaving a number of unfinished works.

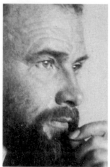

'I am not interested in myself as a subject for painting, but in others, particularly women...'

Beautiful, sensuous and above all erotic, Gustav Klimt's paintings speak of a world of opulence and leisure, which seems aeons away from the harsh, post-modern environment we live in now.

Gustav Klimt

Photography

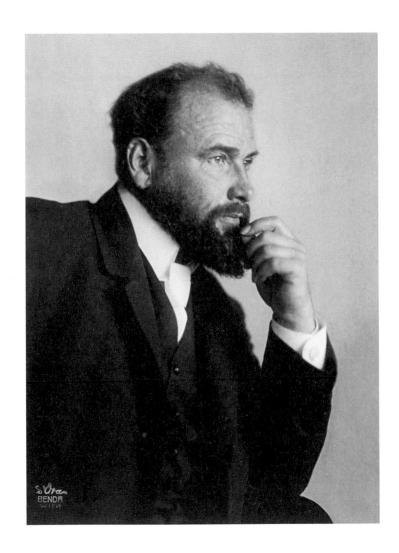

The subjects he treats – allegories, portraits, landscapes and erotic figures – contain virtually no reference to external events, but strive rather to create a world where beauty, above everything else, is dominant. His use of colour and pattern, profoundly influenced by the art of Japan, ancient Egypt, and Byzantine.

Male Nude Walking Facing Right

1877-79
pencil, 43 x 24 cm

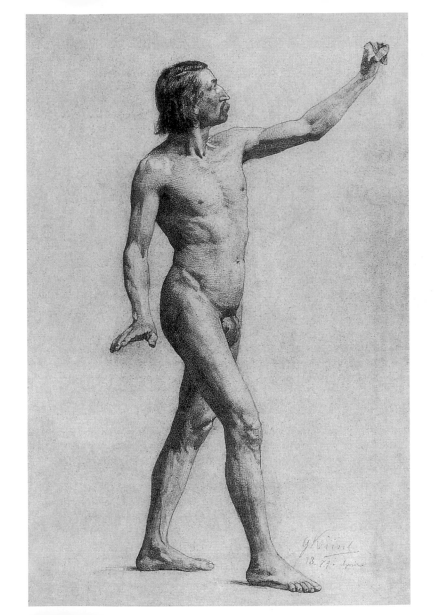

11

Ravenna, the flat, two-dimensional perspective of his paintings, and the frequently stylized quality of his images form an oeuvre imbued with a profound sensuality and one where the figure of woman, above all, reigns supreme.

Klimt's very first works brought him success at an unusually early age.

Fable

———

1883
oil on canvas, 85 x 117 cm
Historisches Museum Vienna

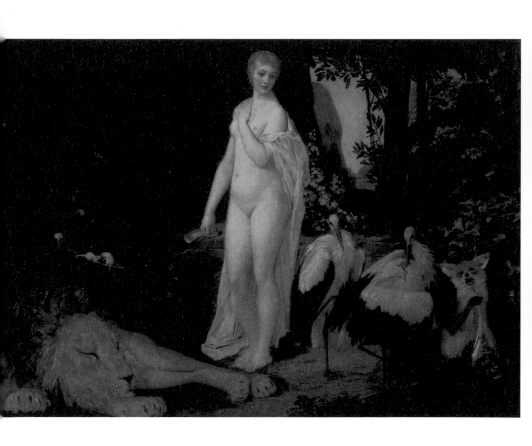

He came from a poor family where his father, a goldsmith and engraver, could scarcely maintain his wife and family of seven children.

Gustav, born in 1862, obtained a state grant to study at the Kunstgewerbeschule (the Vienna School of Arts and Crafts) at the age of 14.

The Idyll

1884
oil on canvas, 50 x 74 cm
Historisches Museum Vienna

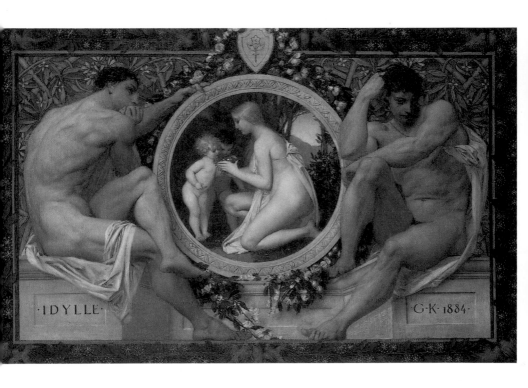

His talents as a draughtsman and painter were quickly noticed, and in 1879 he formed the Künstlercompagnie (Artists' Company) with his brother Ernst and another student, Franz Matsch. The latter part of the nineteenth century was a period of great architectural activity in Vienna.

Fairy Tale

1884
black pencil, ink and lavish, 63.9 x 34.3 cm
Museum der Stadt Wien, Vienna

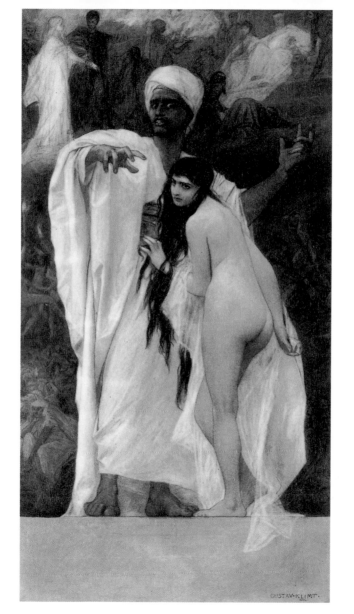

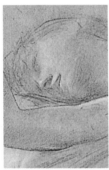

In 1857, the Emperor Franz Joseph had ordered the destruction of the fortifications that had surrounded the medieval city centre. The Ringstrasse was the result, a budding new district with magnificent buildings and beautiful parks, all paid for by public expenses.

Female Nude Lying Down

1886-1887
study for The altar of Dionysos
black pencil with white highlights
28.7 x 42.5 cm
Vienna

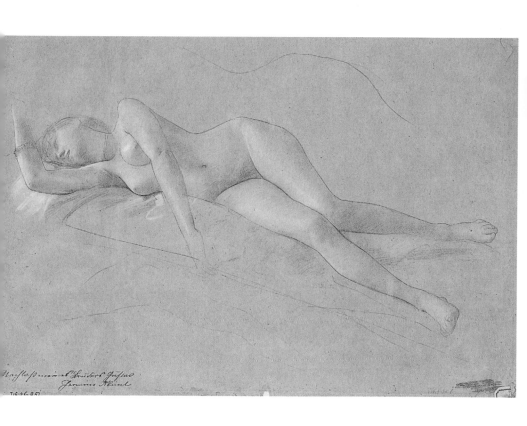

Therefore, the young Klimt and his partners had ample opportunities to show their talents, and they received early commissions to contribute to the decorations for the pageant organized to celebrate the silver wedding of the Emperor Franz Joseph and the Empress Elisabeth.

Man's Head Lying Down
(Painting from The Ceiling of The Imperial Venetian Theatre)

1886-1888
Black chalk, white highlights, 28 x 43 cm
Graphische Sammlung Albertina, Vienna

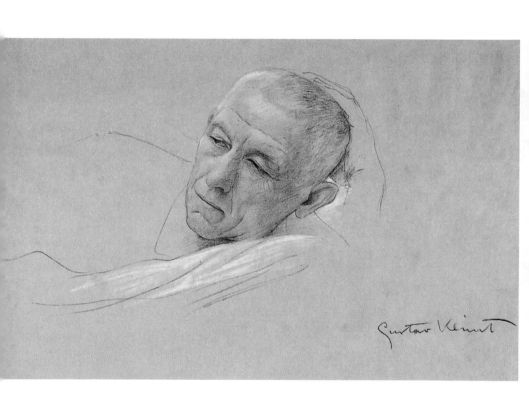

In the following year, they were commissioned to produce a ceiling painting for the Thermal Baths in Carlsbad. Other public commissions soon followed. When one examines these early works, such as *Fable, The Idyll*, or indeed one of Klimt's earliest drawings, *Male Nude* , it is clear that he is a painter of great skill and promise,

The Death of Juliet

1886
black pencil with white highlights
27.6 x 42.4 cm, Vienna

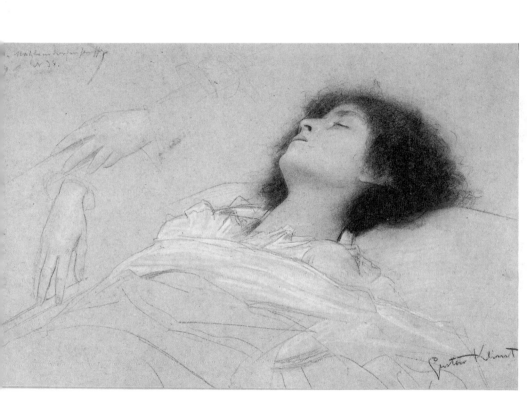

but remains entirely within the accepted contemporary norms in his depiction of academic and allegorical subjects. The women in *Fable* and *Idyll* are plump, adroitly draped in plain textiles, their hair smoothly pulled back behind the neck. Neither would look out of place in the eighteenth or even seventeenth century. Their sensuality is matronly, motherly, their nudity decorous rather than exciting.

Taormina's Theater

———————

1886-1888

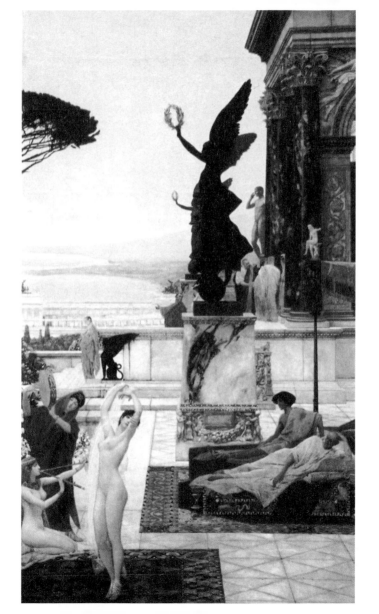

In the past, pubic hair had – if this part of the body was revealed at all – traditionally been glossed over into a smooth and unsuggestive 'v' reminiscent of modern-day children's dolls. Many early medieval or Renaissance paintings which had shown even the suggestion of male or female genitalia had suffered the absurd addition of a floating fig leaf painted in by later, more prudish, souls.

Room of The Old Burgtheater

1888, Vienna

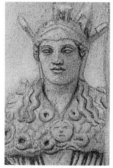

But even as early as 1896, Klimt had begun to be more explicit in the way he chose to depict the human figure. There is, for example, an interesting difference between the final drawing for *Sculpture* and the painting itself. In the drawing we already see the trademark loose, wild, dark hair and the faintest traces of pubic hair.

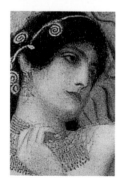

Allegory of "Sculpture"

1889
pencil and watercolour, 44 x 30 cm

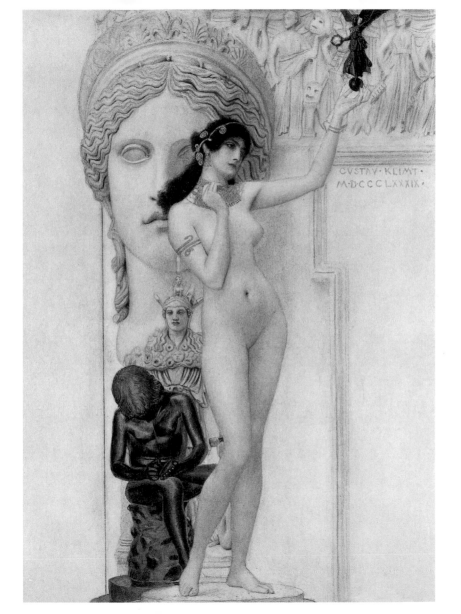

The woman gazes directly at the viewer, standing as if caught naked in her bedroom doorway, summoning the viewer to caress her. The painting, by contrast, has reverted to a more traditional style: gone the frontal stance, back the classical sculptural pose. Up goes the hair and the pubic hair disappears.

Joseph Pembaur's Portrait

1890
oil on canvas, 69 x 55 cm
Innsbruck, Austria

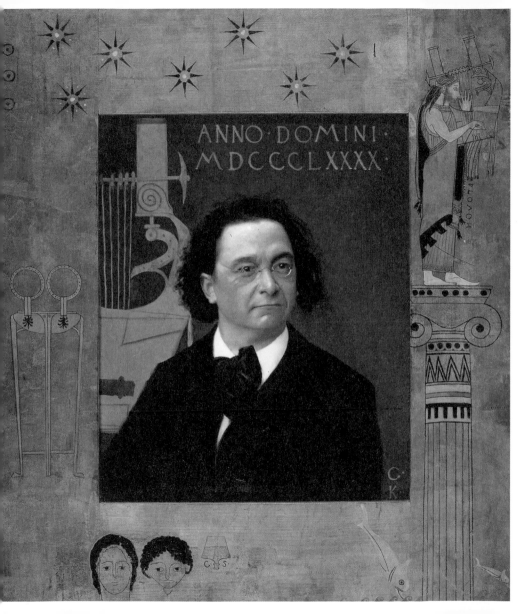

ANNO·DOMINI·
MDCCCLXXXX·

These early commissions established Klimt as a successful and prominent artist. Following the death of his father and brother Ernst in 1892, there seems to have been a distinct cooling-off in the working relationship between Klimt and Matsch as Klimt began to explore more adventurous waters.

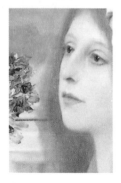

Young Girls with Roses Bunch

1890
oil on canvas, 55 x 128.5 cm
Wadsworth Atheneum, Hartford (Connecticut)

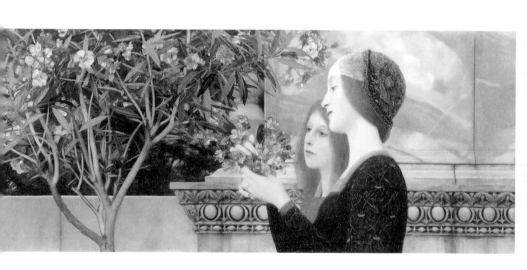

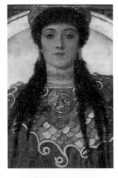

In 1894, Matsch moved out of their communal studio, and in 1897 Klimt, together with his closest friends, resigned from the Künstlerhausgenossenschaft (the Co-operative Society of Austrian Artists) to form a new movement known as the Secession, of which he was immediately elected president.

Ancient Greek Art I

—————

1890-1891
Kunsthistorisches Museum, Vienna

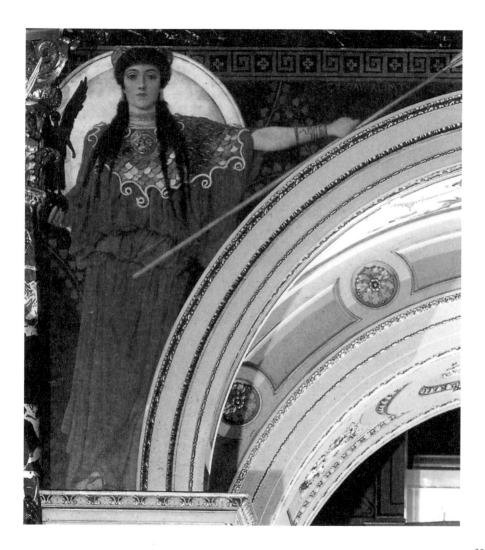

The Secession was a great success, holding both a first and a second exhibition in 1898. The movement made enough money to commission their very own building, designed for them by the architect Joseph Maria Olbrich.

Above the entrance was their motto: 'To each age its art, to art its freedom'.

Egyptian Art II

1890-1891
Kunsthistorisches Museum, Vienna

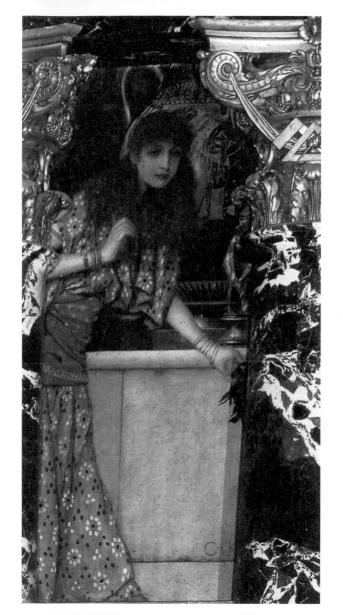

The Secession not only came to represent the best of Austrian art, but was able to bring to Vienna French Impressionist and Belgian Naturalist works, which had never before been seen by the Austrian public. Klimt was undoubtedly the central figure in this young and dynamic movement, but his success as a modern artist went hand in hand with the loss of his status as an acceptable establishment painter.

Egyptian Art II

1890-1891
Kunsthistorisches Museum, Vienna

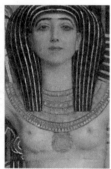

As he moved away from his traditional beginnings, he soon found himself at the centre of a series of scandals, which were to change his entire career. In 1894, Klimt and Matsch had received a commission to produce a series of paintings for the University of Vienna. The subjects Klimt was assigned were Philosophy, Medicine, and Jurisprudence.

Egyptian Art I
(Young Girl with Horus)

1890-1891
Kunsthistorisches Museum, Vienna

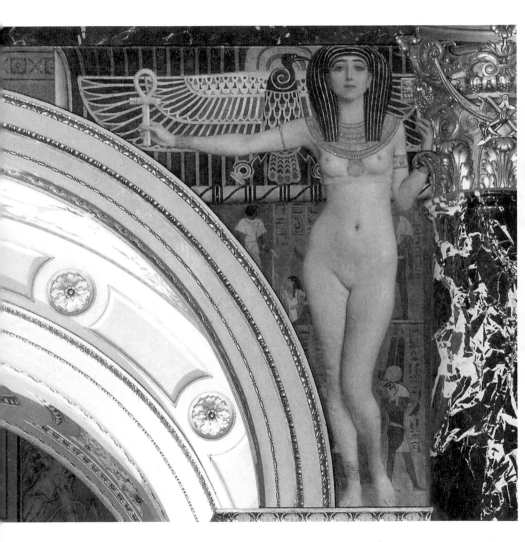

The nature of the commission can be easily imagined: The university would be expecting a series of dignified, formal paintings in classical style depicting the wisdom of philosophers, the healing virtues of medicine, and doubtless a statuesque blindfolded female figure holding a pair of scales and representing justice.

Portrait of a Woman
(Mrs. Heymann?)

about 1894
oil on wood, 39 x 23 cm
Kunsthistorisches Museum, Vienna

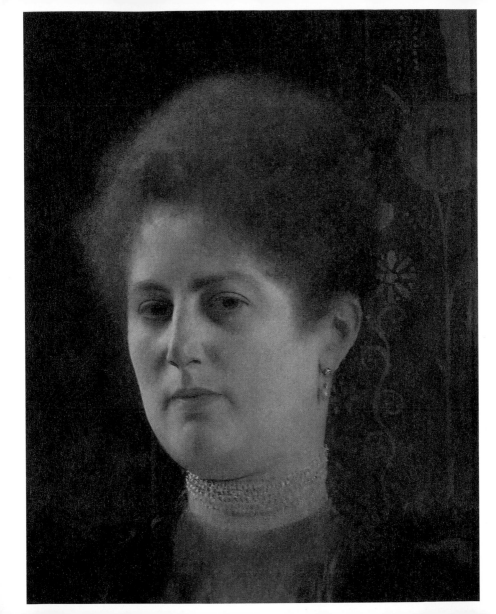

What they got, several years and much hard work later, caused such a scandal that Klimt eventually repaid the advances he had received and took the paintings back. Despite the fact that on its first showing in Paris at the World Fair in 1900 *Philosophy* won him the gold medal, the Viennese were not of the same opinion as the French as to the painting's merits.

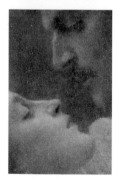

The Love

———

oil on canvas, 60 x 44 cm
Museum der Stadt Wien, Vienna

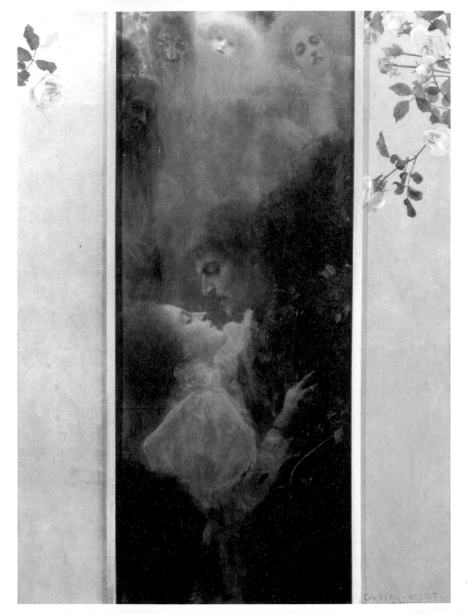

The first appearance of the unfinished *Medicine* in the following year caused even greater controversy. It is difficult to fathom precisely what Klimt meant to say about medicine in this painting. The vision is chaotic, almost hellish. Its skulls, wrinkled elderly figures and mass of human bodies speak of human suffering, not of its cure.

Music I

———

1895
Bayerische Staatsgemäldesammlungen, Munich

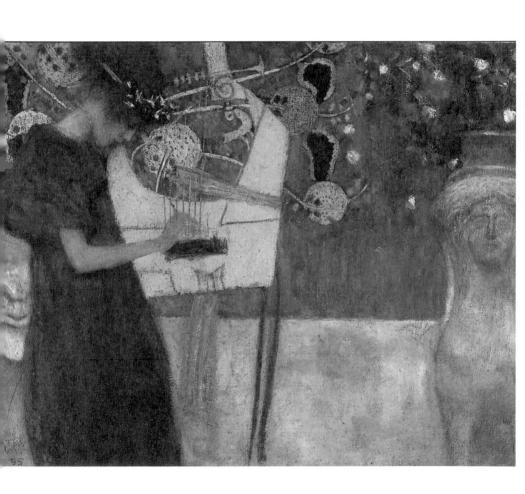

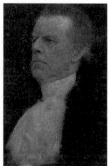

The viewer's eyes are drawn inevitably to the two striking female figures at the bottom and top left of the painting. Clearly the figure at the bottom represents Medicine itself – the traditional symbol of the serpent suggests this – but this art nouveau woman, enlaced in gold ornament, looks more like a priestess likely to sacrifice a sick person than to heal them.

Portrait of Josef Lewinsky

1895
oil on canvas, 60 x 44 cm
Osterreichische Galerie, Vienna

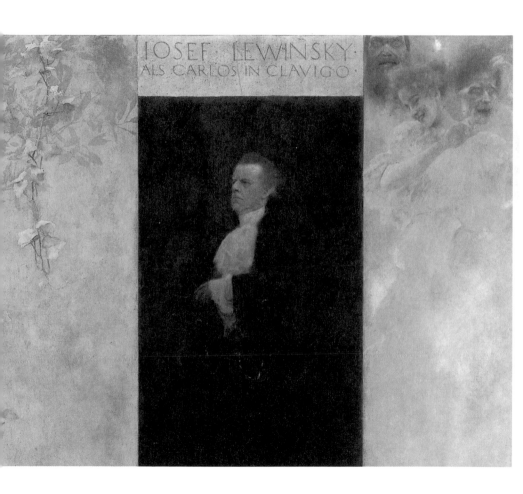

49

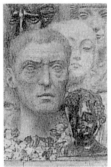

The naked woman at the top of the picture is remarkable for the dynamic abandonment of her pose. Our eyes are inevitably drawn to the woman's groin as she flings out her arms in a parody of crucifixion. The sketch for the figure shows very clearly how bold and excellent a draughtsman Klimt was: the heavy line and subtle shading lead our eyes firmly to the woman's pubic hair.

Final Drawing for Allegory
of The "Sculpture"

1896

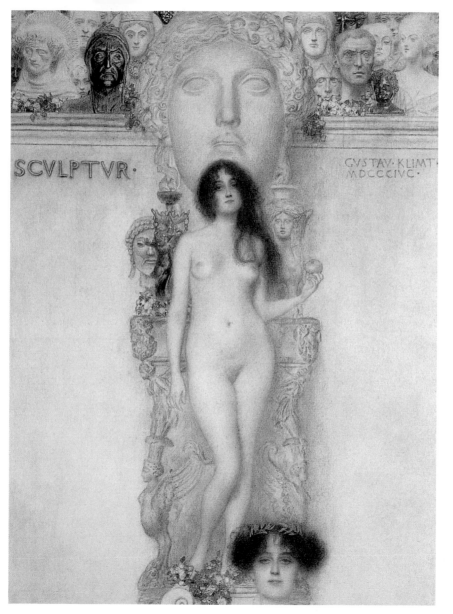

SCVLPTVR·

GVSTAV·KLIMT·
MDCCCIVC·

51

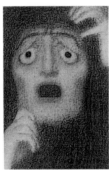

Interestingly though, in the sketch the woman looks as if she might have posed lying down or leaning against something, whereas in the painting she is standing precariously unsupported, as if about to fall. Both these and the other female figures around them represent a complete departure from the rotund, comfortable women of the traditional nineteenth century academic style.

Final Drawing
for The Allegory "Tragedy"

1897
Black chalk, wash, gold and white highlights
42 x 31 cm
Kunsthistorisches Museum, Vienna

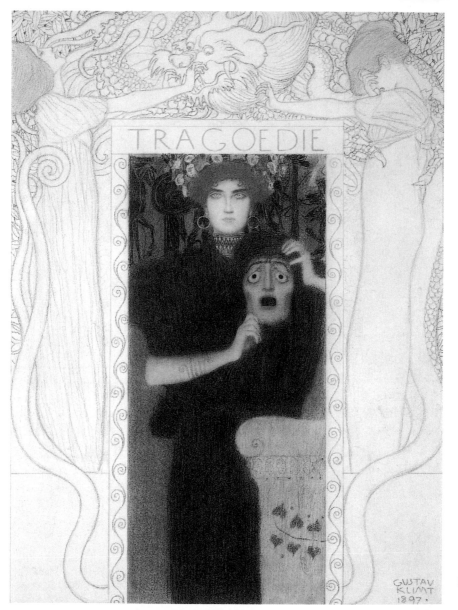

TRAGOEDIE

GUSTAV
KLIMT
1897·

53

Klimt's women are long-haired, slender, lithe, and possess a sexual awareness that is both alluring and almost threatening in its directness. Klimt's contemporary Berta Zucker-kandl makes the following comment in her memoirs: "Klimt had created from Viennese women an ideal female type: modern, with a boyish figure.

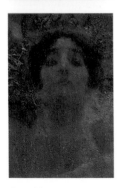

Compositional Project
for "Medicine"

1897-1898
Graphite, 72 x 55 cm
Vienna

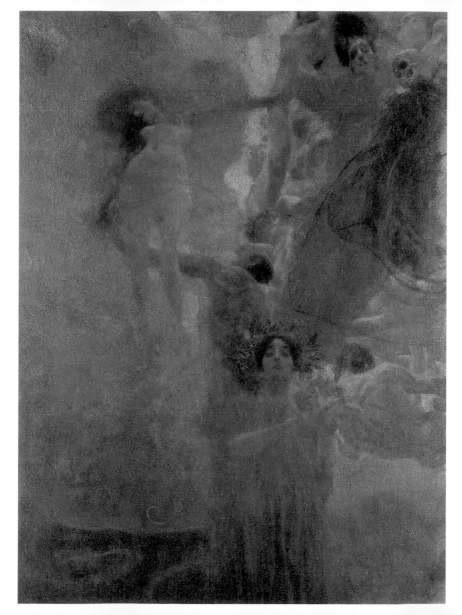

They had a mysterious fascination; although the word 'vamp' was still unknown he drew women with the fascination of a Greta Garbo or a Marlene Dietrich long before they actually existed." (*Ich erlebte fünfzig Jahre Weltgeschichte (I witnessed fifty years of world history)* Stockholm 1939.)

Portrait of a Woman

1897
pastel on velin paper, 51.2 x 27.7 cm
Allen memorial Art museum, Oberlin, Ohio

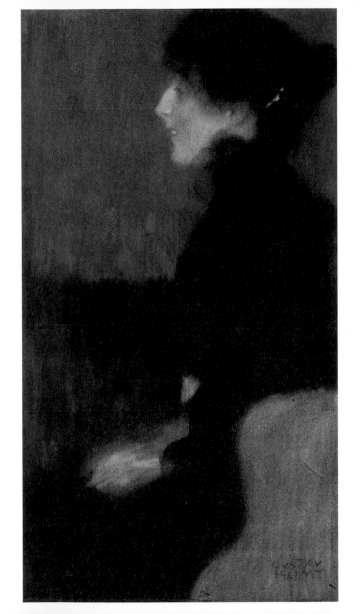

Looking at his 1909 portrait *Woman in a Hat with Feather Boa* it is easy to see the truth of this statement.

The woman's face, half-hidden by feathers and hat, looks not unlike a dark-haired version of Marilyn Monroe. The seductively half-closed eyes certainly echo many Monroe poses.

Woman near The Fire

1897-1898
oil on canvas, 41 x 66 cm
Osterreichische Galerie, Vienna

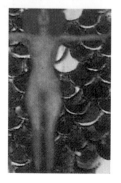

The Secession's fourteenth exhibition in 1902 led to yet another scandal. The exhibition centred around Max Klinger's statue of Beethoven and Klimt had decided to contribute a frieze. The detail shown depicts *Lust, Lechery and Excess,* three allegorical figures designed to occupy part of the central wall of the room where Klinger's statue was exhibited.

Athena Pallas

1898
Oil on canvas, 75 x 75 cm
Historisches Museum, Vienna

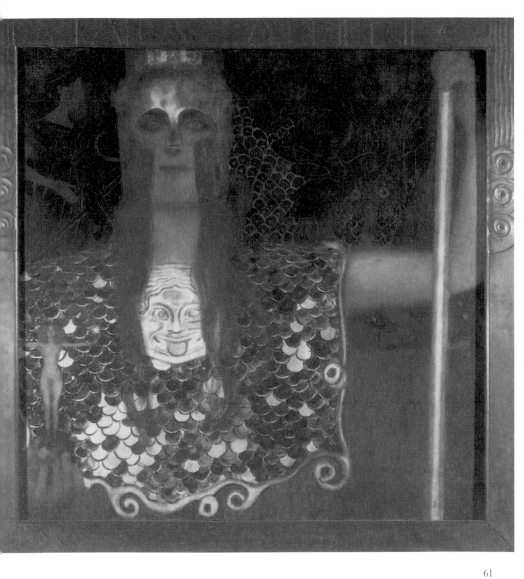

61

Again, Klimt's purpose in choosing precisely these subjects for a tribute to Beethoven remains obscure, but they contain the seeds of many a later work, most notably the trademark use of exotically patterned textiles to form not so much a backdrop to the human figures but to create a composition of which pattern and human figure are equal parts.

Flowing Water

1898
oil on canvas, 52 x 65 cm
Private Collection

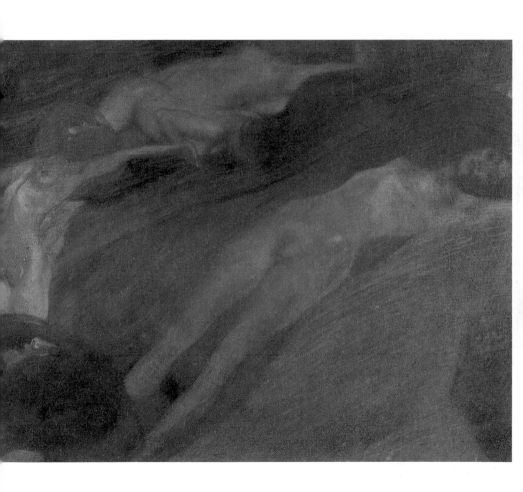

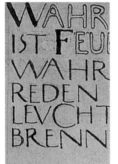

In the figure of *Lust*, shown top left, Klimt uses the woman's hair both to hide her sex and to draw attention to it. The superb figure of *Excess* resembles not so much a woman as an oriental pasha, a man whose corpulence has reached such an extent that his chest has expanded to form female breasts.

Final Drawing
for "Nuda Veritas"

1898
Black chalk, pencil, indian ink, 41 x 10 cm

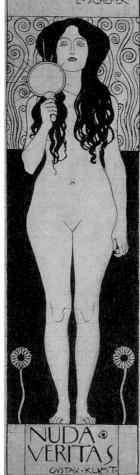

WAHRHEIT
IST FEUER UND
WAHRHEIT
REDEN HEISST
LEVCHTEN UND
BRENNEN ·

L · SCHEFER ·

NUDA
VERITAS

GVSTAV · KLIMT ·

Conservative Viennese society was once again profoundly shocked by these images, much in the same way that modern-day exhibition-goers are shocked by a Damien Hirst. Klimt's contemporary Felix Salten relates: "Suddenly an exclamation came from the centre of the room: 'Hideous!'

Portrait of Sonja Knips

1898
Osterreichische galerie, Vienne

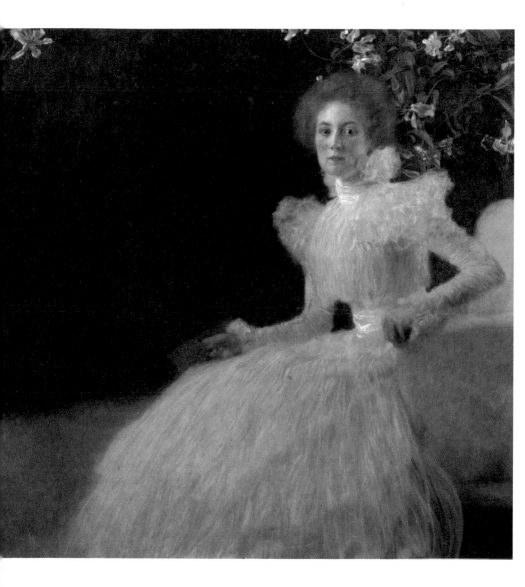

An aristocrat, a patron and collector, whom the Secession had let in today together with other close friends, had lost his temper at the sight of the Klimt frescoes. He shouted the word in a high, shrill, sharp voice... he threw it up the walls like a stone. 'Hideous!'" Klimt's only response to this, as he worked away on the scaffolding above, was an amused glance in the direction of the departed man.

Expositional Wallpaper
for Secession I

———————

1898
lithography, 62 x 43 cm
private collection, New York

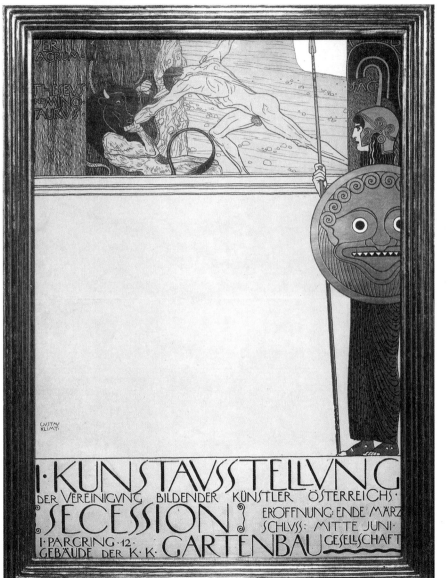

This calm response perhaps best typifies Klimt's reaction to the scandals he caused. Although the faculty paintings ensured that Klimt swiftly lost the patronage of the Emperor and other establishment figures, he was fortunate enough to be able to earn an extremely comfortable living from painting portraits and thus did not have to worry about this loss.

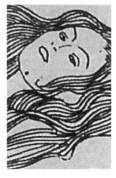

Fish Blood

———

1898

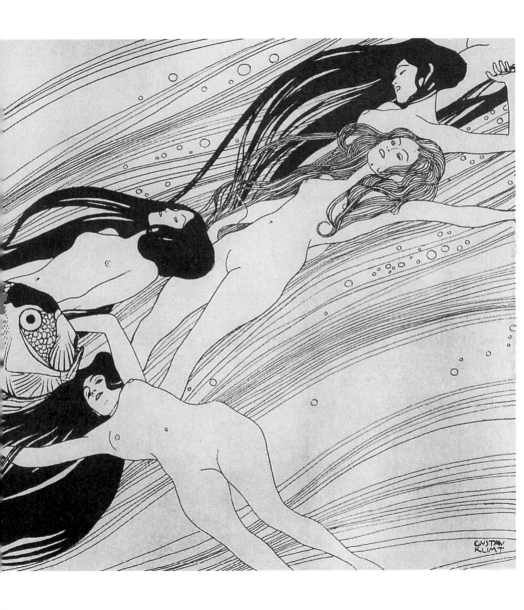

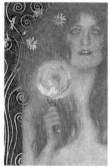

Three times, however, he was refused a professorship of the Academy. Only in 1917 was he offered the small consolation of being made an honorary member. It must be remembered that despite their tastes for balls, the opera, theatre and music, the Viennese upper classes were extremely conservative in their tastes.

Nuda Veritas

1899
Oil on canvas, 252 x 56 cm
Vienna

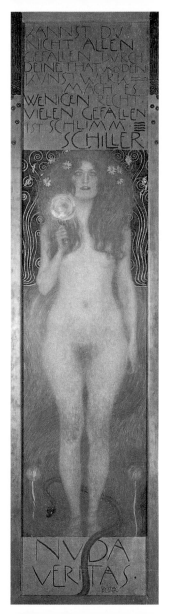

KANNST DV
NICHT ALLEN
GEFALLEN DVRCH
DEINE THAT VND DEIN
KVNST WERK
MACH ES
WENIGEN RECHT.
VIELEN GEFALLEN
IST SCHLIMM.
SCHILLER

NVDA
VERITAS.

A combination of strict Roman Catholicism and rigid social mores kept the them buttoned up, at least on the surface. And whilst people were only too happy to indulge in all sorts of sensual pleasures that were sanctioned by society – the waltz, for example – they did not appreciate having openly erotic, ugly or sexual subjects thrust before them, a double standard which speaks volumes about the fin de siècle morality.

After the Rain

1899
oil on canvas, 80 x 40 cm
Osterreichische Galerie, Vienna

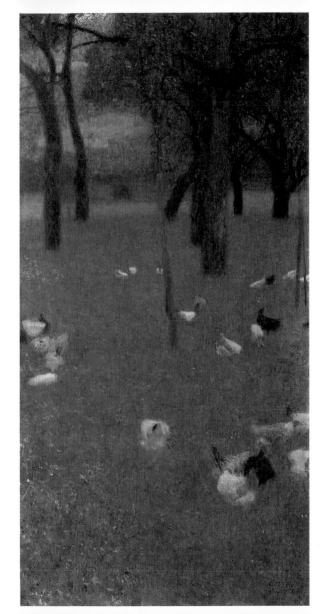

The Vienna into which Klimt was born was a city perched uncomfortably on the cusp of two eras. Then, it was still the capital of a far-reaching Empire of over fifty million inhabitants, ruled by the Emperor Franz Joseph. By the time of Klimt's death in 1918, the Habsburg Empire itself had only seven months left to live.

Water Sprites
(Silver Fishes)

1899
oil on canvas, 82 x 52 cm
Zentralsparkasse, Vienne

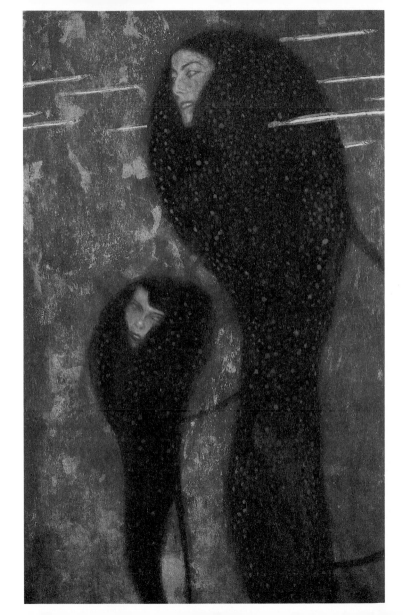

Austria then became a tiny nation state of seven million inhabitants, three million of whom were concentrated around Vienna. Twenty years later it was absorbed by Nazi Germany under the leadership of Adolf Hitler, himself, ironically, born on Austrian soil. The period of decline had begun even before Klimt was born.

Schubert at Piano

1899

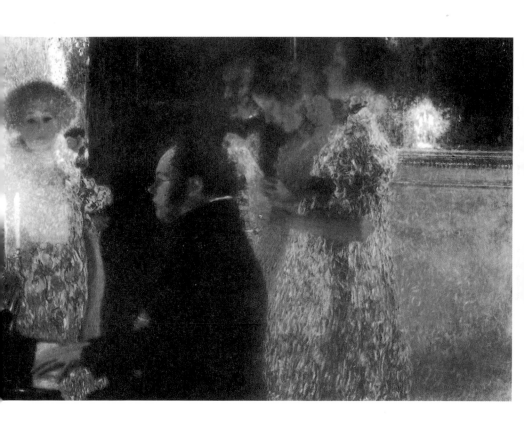

Military defeats across the Empire sounded warning bells for future stability, whilst Vienna was filling up with Czechs, Gypsies, Hungarians, Poles, Jews, and Romanians – immigrants from the poorest parts of the Empire, all in search of work, often living in appalling conditions.

Cowshed

———

1899
oil on canvas
Neue Galerie der Stadt Linz, Austria

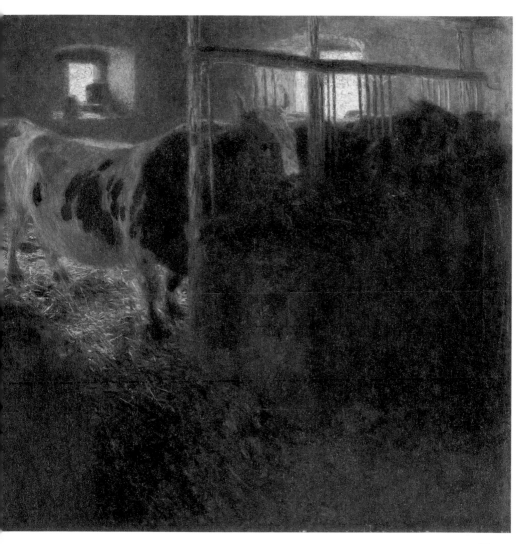

The wealthy Viennese, however, chose not to acknowledge these signals of future trouble but rather to ignore the outside world and immerse themselves in a whirl of pleasurable activities. This was a period of great musicians – Brahms, Bruckner, Strauss the younger, Schönberg, Mahler and, of course, Franz Lehàr, creator of the light operettas so beloved of the Viennese.

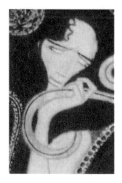

Friezes of Beethoven

1899

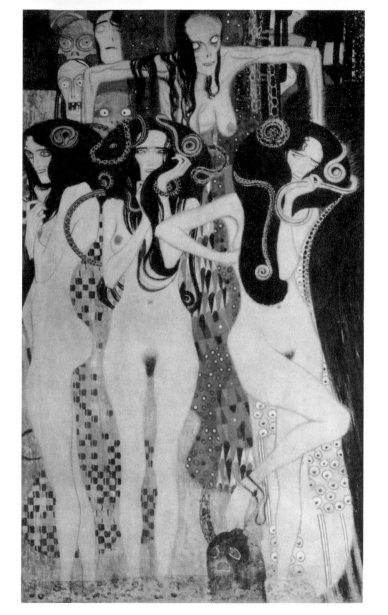

It was also the era of Sigmund Freud, Alfred Adler, Arthur Schnitzler, and amidst all this, Klimt. It is one of the most tantalising facts about a man so well-known in times comparatively recent to our own that almost nothing concrete is known about Klimt's personal life, a fact largely due to his own reticence on the subject.

Two Studies of Standing Nude
for The Composition "Medicine"

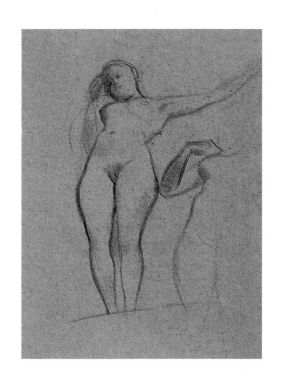

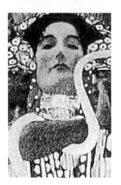

Whilst the facts of his artistic career are well-charted, knowledge of his private life depends entirely on hearsay. On the one hand, he is depicted as a ladies' man, built like a peasant, strong as an ox, sleeping with countless women, including all of his models.

Medicine
───────
1900-1907
oil on canvas, 430 x 300 cm

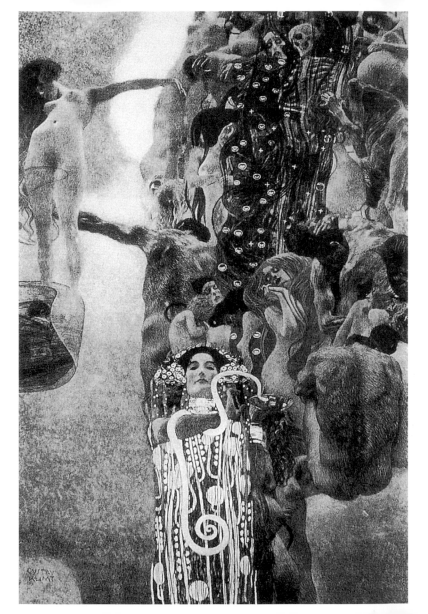

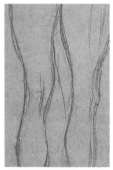

On the other hand, he is seen as a hypochondriac and a confirmed bachelor of regular habits, living with his mother and sisters while keeping a studio in the suburbs to which he went to work regularly every day: "Klimt's daily routines were very bourgeois.

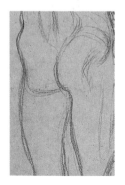

Two Lovers

1901-1902
study for the frieze Beethoven
black pencil, 45 x 30.8 cm
Vienna

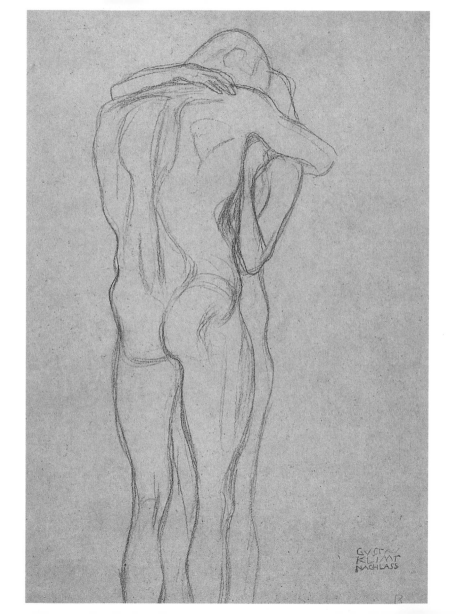

GVSTAV
KLIMT
NACHLASS

He was so engrossed in them that any divergence from his normal course was a horror to him; going anywhere was a major event, and a big trip was only conceivable if his friends did all the shopping for him beforehand, down to the smallest detail."

Island on the Attersee

about 1901
oil on canvas, 100 x 100 cm
Private Collection

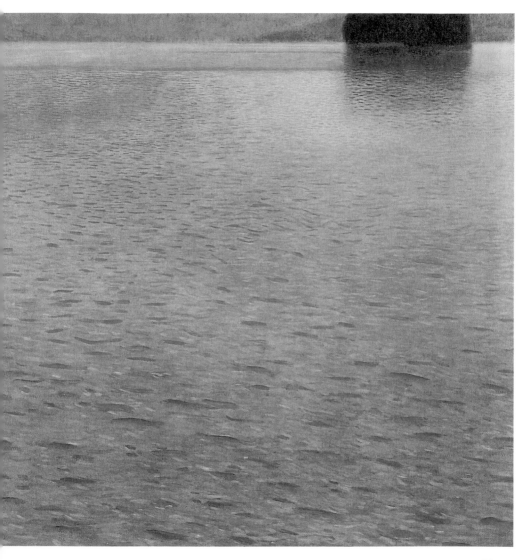

(Hans Tietze, *Gustav Klimts Persönlichkeit nach Mitteilungen seiner Freunde*, 1919) Klimt never married, but had a long relationship with Emilie Flöge, the sister of his brother Ernst's wife. In 1891, Ernst had married Helene Flöge, one of two sisters who ran a fashion house in Vienna.

Red Fish

———

1901-1902

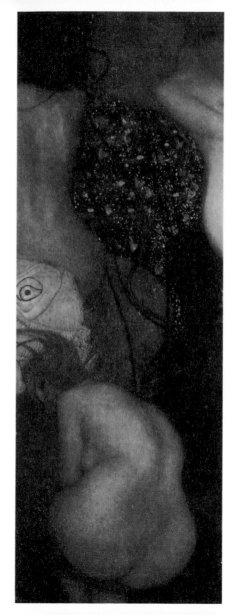

The marriage only lasted fifteen months, but through Helene Gustav had met Emilie.

From around 1897 onwards, he spent almost every summer on the Attersee with the Flöge family, periods of peace and tranquillity, which produced the landscape paintings constituting almost a quarter of his entire oeuvre.

Judith I

1901
Oil on canvas, 84 x 42 cm
Osterreichische Galerie, Vienna

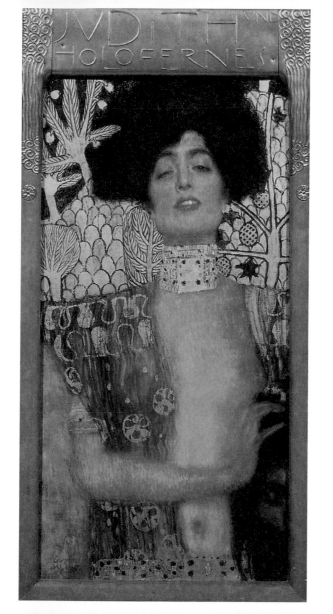

95

The exact nature of Klimt's relationship with Emilie Flöge remains unknown. They never lived together, and although it was Emilie whom Klimt requested on his death bed, there has always been a great deal of speculation as to whether they were actually lovers.

Music
———
1901
lithography

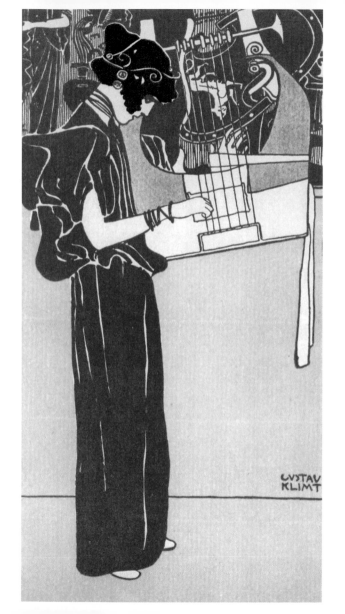

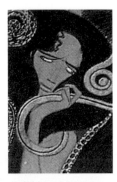

Klimt corresponded extensively both with Emilie and with Marie (Mizzi) Zimmerman, who was the mother of two of his three illegitimate children. To Marie he writes with great affection and in detail about his work and daily life, whilst to Emilie he appears to write merely in order to communicate information concerning travel arrangements and other such neutral details.

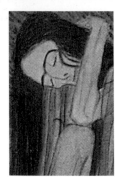

The Beethoven-Frieze (Detail)

1902
Casein on plaster, H. 220 cm
Österreichische Galerie, Vienna

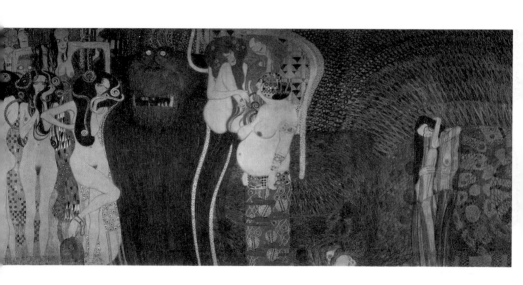

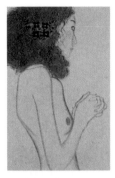

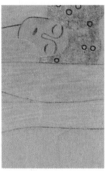

But who is to tell where the truth ultimately lies? It is perfectly possible that more personal correspondence between Klimt and Emilie did exist, but was subsequently destroyed. His 1902 portrait of Emilie shows an attractive young woman wearing one of her own dresses, many of which Klimt designed for her fashion house, as well as jewellery and textiles.

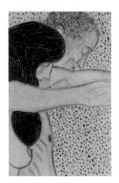

The Beethoven-Frieze:
The Envy, The Luxury and The Excess (Detail)

1902
Casein on plaster, H. 220 cm
Osterreichische Galerie, Vienna

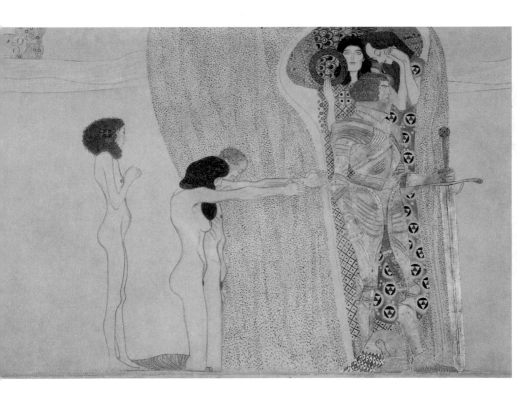

It's a remarkably subdued painting, with just a subtle, tantalising hint of sensuality in the light patch of skin just above the bodice, suggesting the hidden breast beneath. How different from the 1903 painting *Hope I*, which depicts a naked and heavily pregnant woman, Herma, one of Klimt's favourite models.

The Beethoven-Frieze (Detail)
The Envy, The Luxury and The Excess (Detail)

1902
casein on plaster, H. 220 cm
Osterreichische Galerie, Vienna

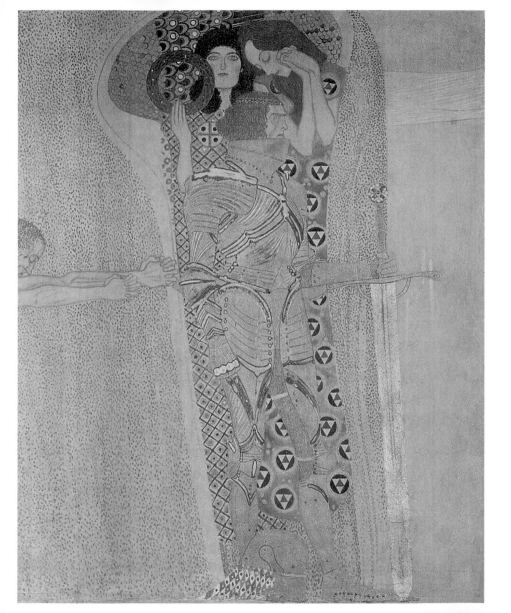

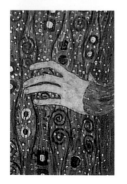

The story goes that one day Herma, whom Klimt apparently described as having a backside more beautiful and more intelligent than the faces of many other models, failed to turn up for work. Klimt, who took very good care of his models, began to worry and finally sent someone to find out if she was ill.

Portrait of Emilie Flöge

1902
oil on canvas, 181 x 84 cm
Historisches Museum der Stadt Wien, Vienna

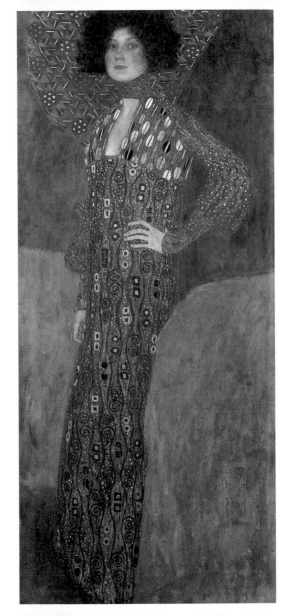

Upon hearing that she was not ill but pregnant, Klimt insisted that she came to work anyway. She then became the model for *Hope I* . This fragile, slender woman looking calmly out at the viewer is anything but maternal. Her figure, apart from her distended stomach, is still that of a young woman, thin to the point of skinniness.

Forest of Beech Trees I

about 1902
Oil on canvas, 100 x 100 cm
Dresden

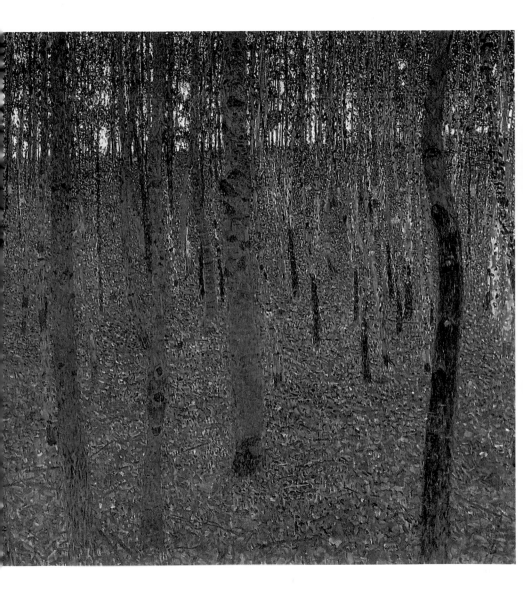

Her hair is crowned with flowers as if she were a bride. Depending on one's point of view, her direct gaze and unobscured nakedness shown in profile for maximum effect, are either pointing out the obvious consequences of sex, or inviting a still-sexual response to her body.

Young Girl with a Blue Veil

1902-1903
oil on canvas, 67 x 55 cm
private collection

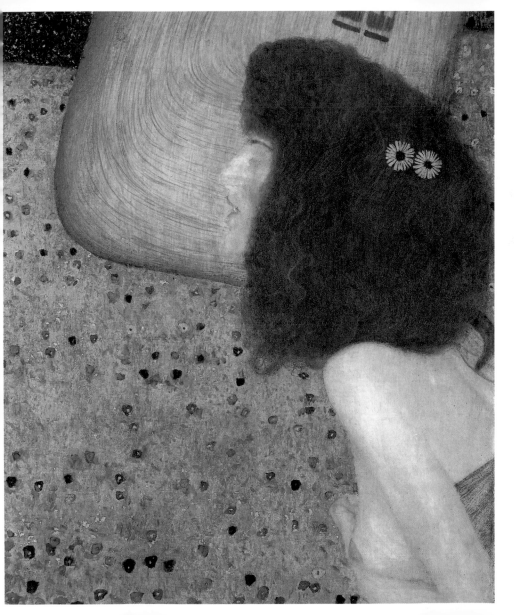

The later *Hope II*, painted in 1907-8, has a far more maternal feel. The woman's breasts are full and large-nippled, her head bowed in a peaceful, almost madonna-like pose. She is enclosed by a fabric that follows an abruptly straight line down her back as if she were actually sitting on a straight-backed chair and was being carried by the figures underneath her.

Marie Moll

1902-1903
pencils, 45.2 x 31.4 cm
Museum der Stadt Wien, Vienna

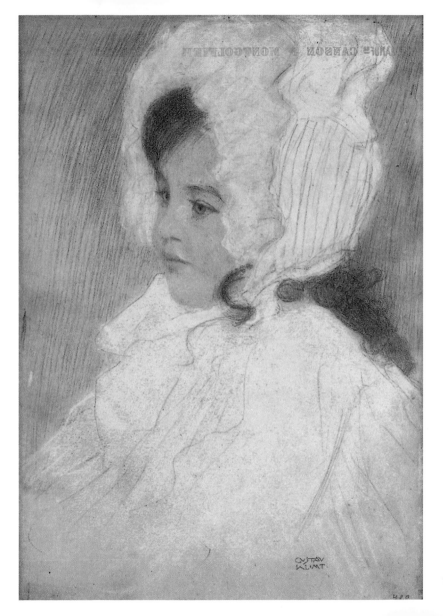

The last great hope of humankind, transported on the backs of other women.

When Klimt died, there were no fewer than fourteen claims that he was the father of an illegitimate child, only three of which were legally upheld – two by Marie Zimmerman and one by Maria Ucicky.

Portrait of Gertha Felsovanyi

1902

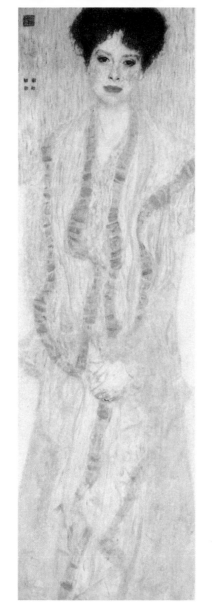

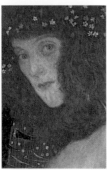

(The child was named Gustav after his father and later went on to become a film director). It is generally assumed that he slept with most of his models. He was certainly known to be very generous towards them. Who knows whether the pregnancies depicted in his paintings had any connection with the painter himself?

Hope I

1903
oil on canvas, 189 x 67 cm

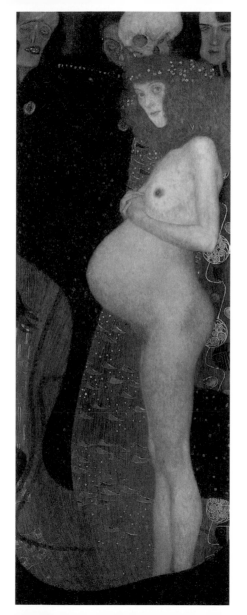

115

If they did, Herma's gaze in *Hope I* takes on an entirely new meaning: a look of reproach? Or one of irony? In his studio, Klimt kept girls available to him at all times, waiting for him in a room next door in case he decided to paint them. Franz Servaes, a contemporary art critic, observed:

Pear Tree

———

oil and casein on canvas, 101 x 101 cm
Harvard University Art Museums

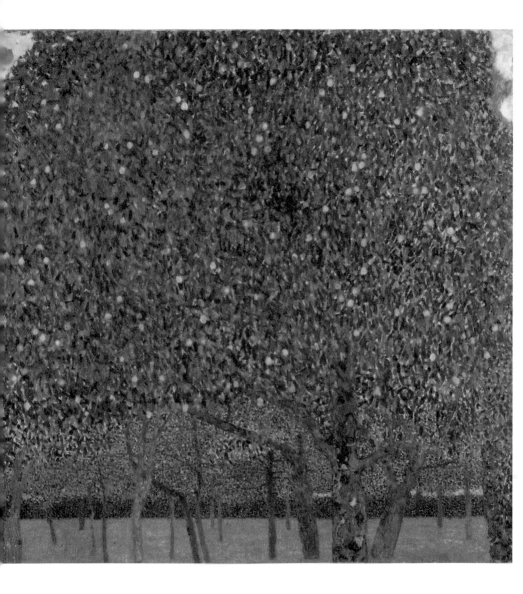

"Here he was surrounded by mysterious, naked female creatures, who, while he stood silent in front of his easel, strolled around his studio, stretching themselves, lazing around and enjoying the day – always ready for the command of the master obediently to stand still whenever he caught sight of a pose or a movement that appealed to his sense of beauty and that he would then capture on a rapid drawing."

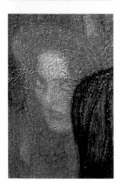

Will-o'-the-Wisp

oil on canvas, 52 x 60 cm
private collection

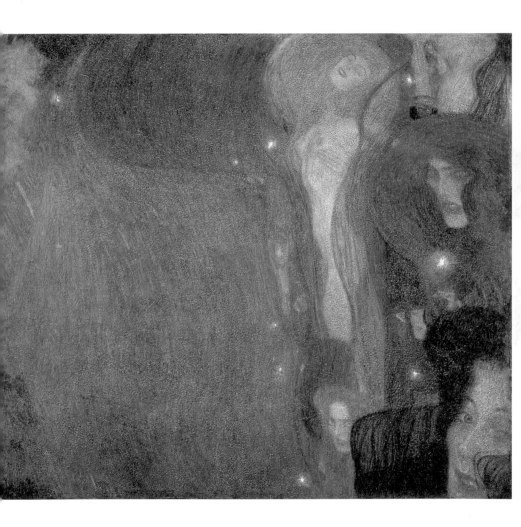

Klimt made sketches for virtually everything he did. Sometimes there were over a hundred drawings for one painting, each showing a different detail – a piece of clothing or jewellery, or a simple gesture. They would lie about his studio in heaps, where his adored cats, it is said, had a habit of destroying them.

Dead's Procession

1903
destroyed in fire 1945

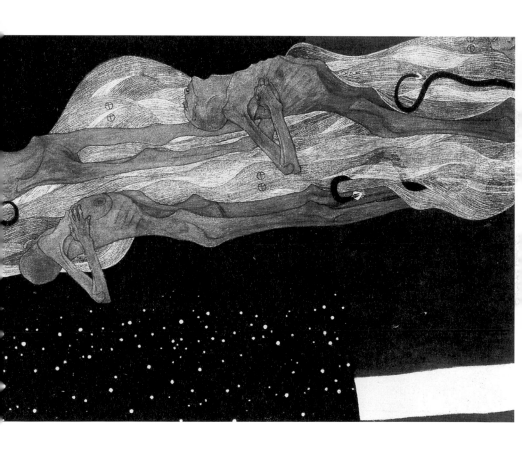

Unfortunately, the bulk of his sketchbooks were destroyed not by cats but by a fire in Emilie Flöge's apartment. Only three of the books survived. The drawings which have survived, however, provide a fascinating insight into Klimt's artistic and personal preoccupations:

The Golden Knight

1903
Oil, Tempera and gold on canvas, 103.5 x 103.7 cm
Aichi Prefectural Museum of Art, Nagoya, Japan

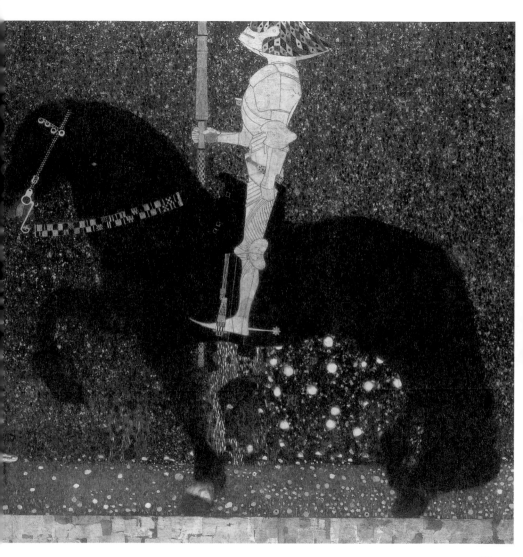

whereas in his paintings nudity and sexuality are covered, almost imprisoned by ornament and textile to be partially and tantalisingly revealed, in his drawings eroticism is open and undisguised. Even during his lifetime, his drawings were by some critics regarded as the best work of his entire oevre, but they would not have been widely seen.

Water Snakes II

1904-1907
Oil on canvas, 80 x 145 cm
Private Collection

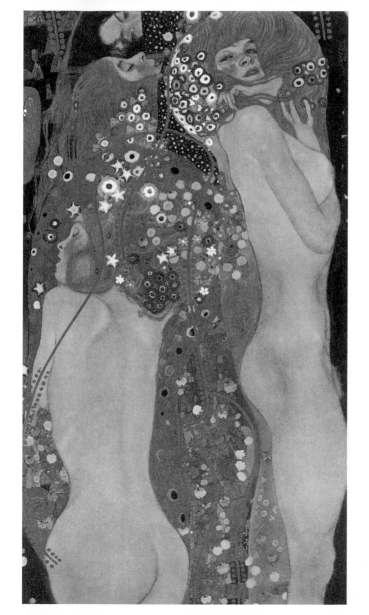

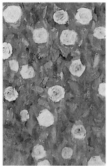

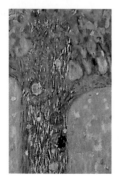

Unlike Schiele, who earned his living from his drawings, Klimt's income was derived entirely from his painting. Drawing for him was either a necessary preparatory process or a form of relaxation, a way of expressing himself spontaneously free from the constraints and detail of oil.

Roses in Trees

oil on canvas, 110 x 110 cm
Musée d'Orsay, Paris

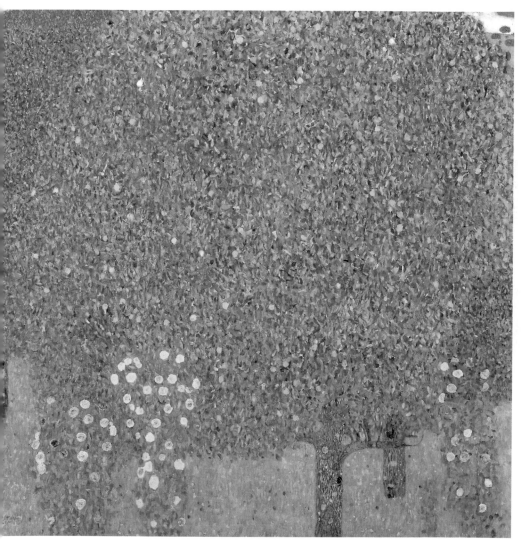

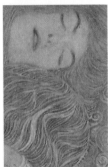

Klimt's drawings not only reveal his mastery of draughtsmanship, they also show an erotic obsession and a sexual freedom quite at odds with the covered-up, repressed society in which he moved. In these drawings there is no visual, temporal, or spacial context, just the women themselves, who were presumably, as earlier described, wandering around his studio in a state of undress.

Water Snakes I

watercolour, 50 x 20 cm
Osterreichische Galerie, Vienna

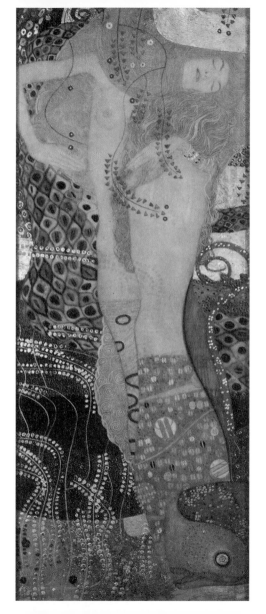

129

He draws them only in outline, omitting any internal modelling or shading of their bodies and almost always drawing attention to their genitalia or breasts by using perspective, foreshortening, distortion or other formal techniques.

The Three Ages of Women

1905
oil on canvas, 178 x 198 cm
Galleria Nazionale d'Arte Moderna, Roma

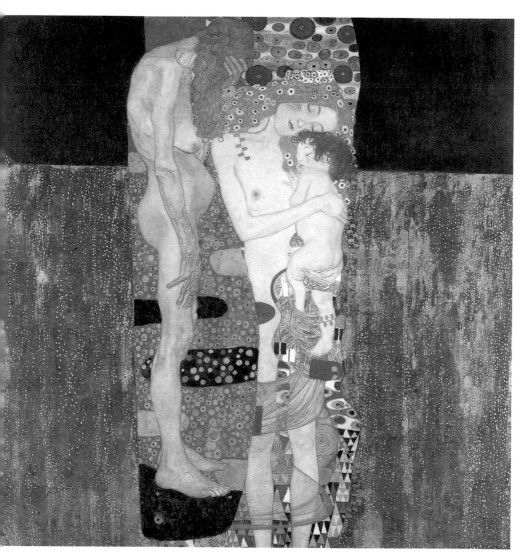

A wonderful example of how a couple of pencil strokes can be used to devastatingly erotic effect is the 1905-6 drawing *Friends Embracing*, in which a tiny circle of darkness draws the viewer's gaze automatically between the woman's legs and her buttocks. The women are frequently depicted masturbating, absorbed in their own sensual pleasures, eyes closed, face slightly averted.

Girlfriends

1905
Black chalk, 45 x 31 cm
Historisches Museum, Vienna

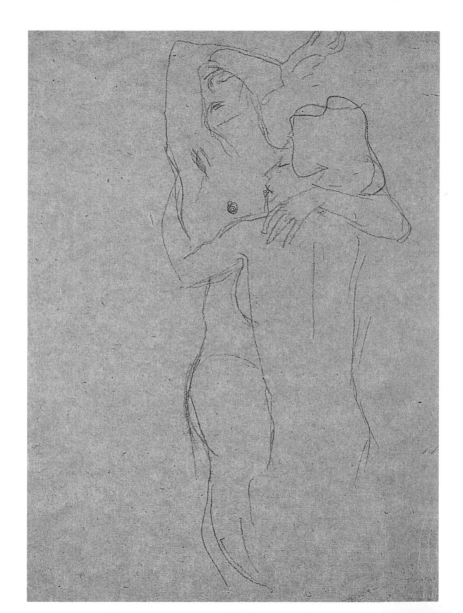

How very at ease these women must have felt with Klimt to allow him to portray them in this way! Langorous, feline, and utterly absorbed, they masturbate delicately, fingers poised above the clitoris, still fully or partially clothed, eyes closed in the imaginary heat of a summer's afternoon.

Portrait of
Margaret Stonborough-Wittgenstein

1905

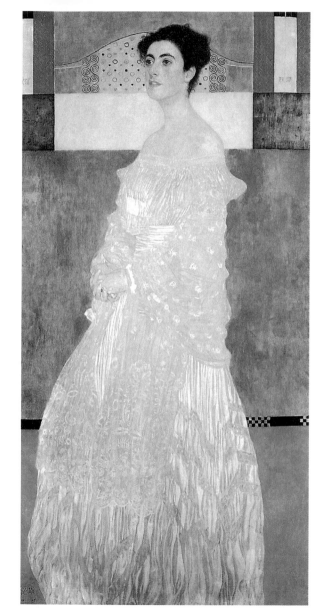

Sometimes Klimt draws in great detail, sometimes it is the overall pose that clearly interests him. Men rarely make an appearance in these drawings, and when they do they are almost uniquely depicted with their back to the viewer. In general, apart from academic studies at art school, men are peripheral figures in Klimt's paintings.

Orchard
———
1905-1906
oil on canvas, 98.7 x 99.4 cm
The Carnegie museum of Art, Pittsburgh

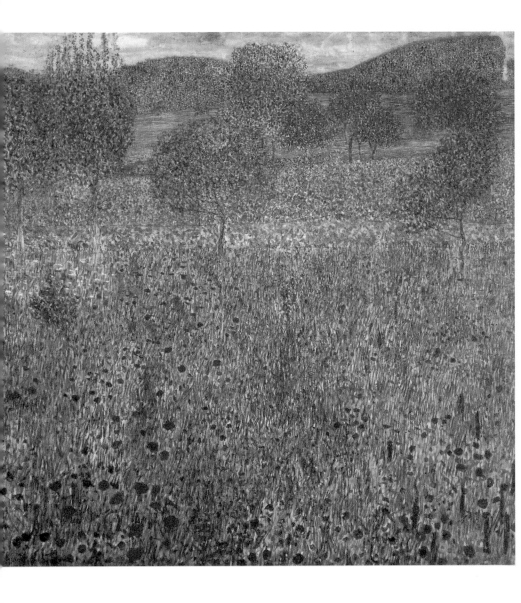

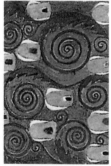

Their faces are rarely shown, and they seem to exist either as voyeurs or simply as the physical partner to a sexual act, of which the woman is the main point of interest for the viewer. What is extraordinary in Klimt's work is that, while expressing his clear admiration for women's beauty, when he shows men and women together he articulates a kind of remoteness, a gulf between the sexes.

The Stocklet Frieze

1905-1909

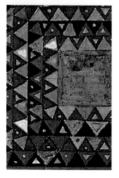

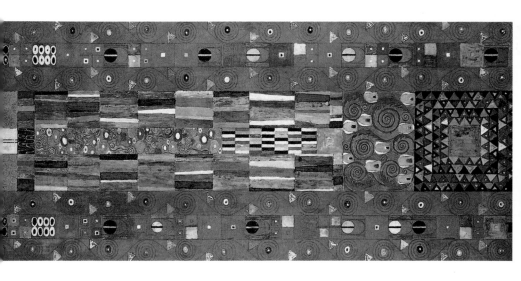

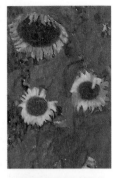

In his painting *The Kiss*, the man's face cannot be seen. He holds the woman up, his hands clasped round her face in a gesture of great tenderness, yet her face is turned away from his embrace: he is offered only her cheek to kiss, and her hand looks almost as if she were trying to pull his away.

Sunflowers Garden

oil on canvas, 110 x 110 cm
Osterreichische Galerie, Vienna

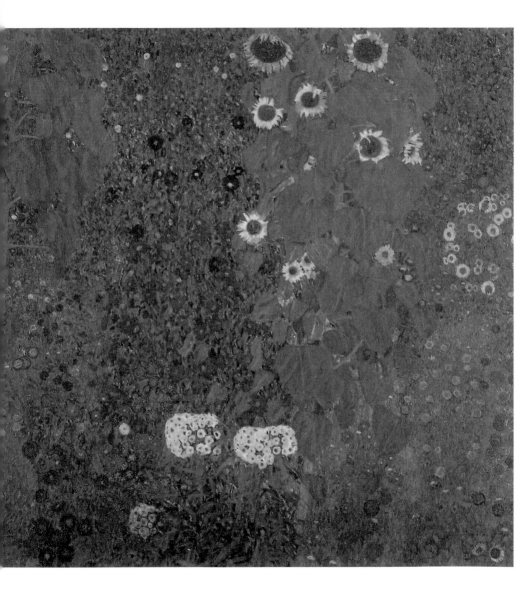

Auguste Rodin's earlier sculpture *The Kiss*, by contrast, shows both lovers fully engaged in their embrace. It is a tender, romantic and sensual moment equally involving both partners. One could assuredly interpret this lack of direct contact in Klimt's painting in other terms – her face is turned towards us so that we can admire its peaceful beauty,

Lovers

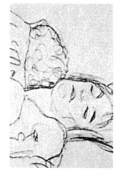

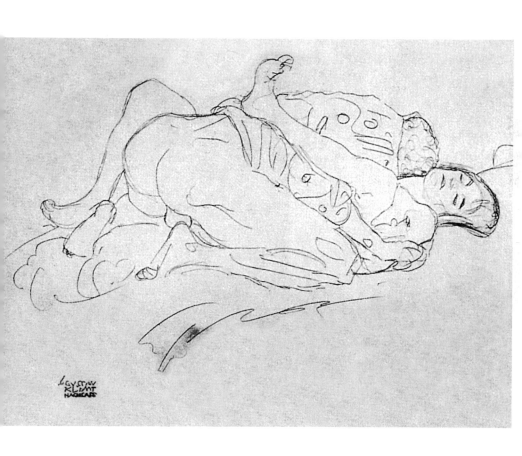

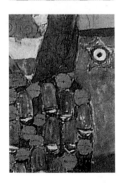

for example – but another sketch of 1903-4 presents a series of images that underline the first interpretation: the figures are seated in a pose similar to that of the lovers in Rodin's sculpture. The man, however, seems unable to make any physical contact with the woman, desperately though he tries.

Waiting
———
about 1905-1909
Osterreichisches Museum, Vienna

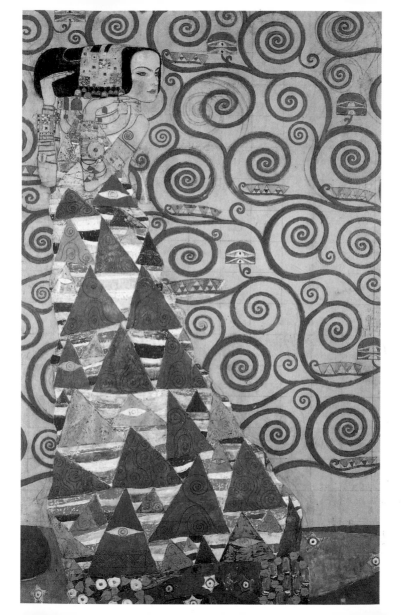

He clasps her to him, leans over her, and finally leans on top of her in an attitude of despair. Are we to infer from this a vision of the world in which men desperately seek love from women who, though appearing open to this contact, actually possess a quiet, independent world quite inaccessible to men?

Tree of Life

about 1905-1909
195 x 102 cm
Museum für Angewandte Kunst, Vienna

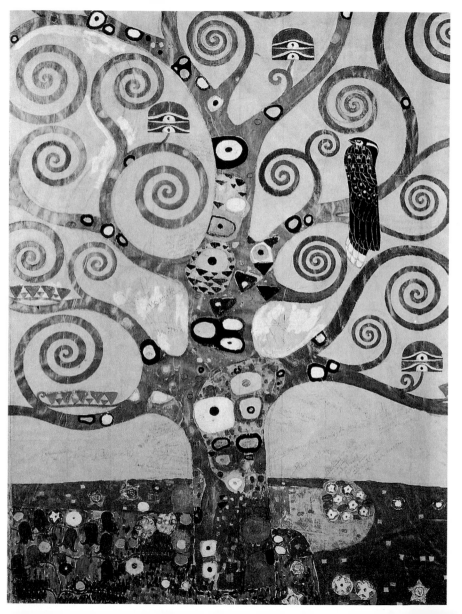

One of Klimt's amorous liaisons might suggest so. Alma Mahler-Werfel (then Schindler) knew Klimt when she was a young girl of seventeen and claims that he was in love with her. She is not a modest diarist by any means, but there is no reason to doubt the truth of the affair, especially in the light of a later letter of apology written by Klimt to her stepfather, Carl Moll.

Accomplishment

about 1905-1909
Osterreichisches Museum, Vienna

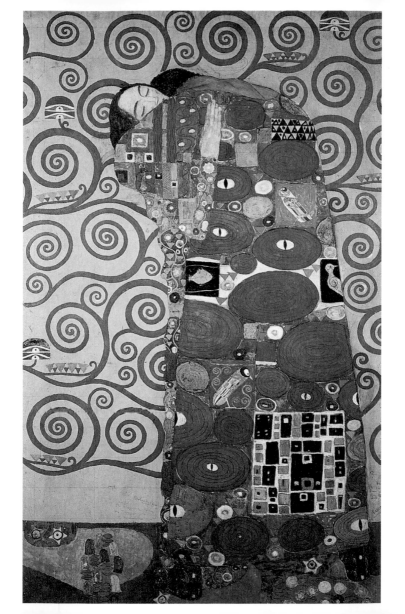

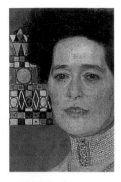

Alma later made something of a career out of having relationships with artists: she was married three times, first to Gustav Mahler, then to the architect Walter Gropius, then finally to the Prague poet Franz Werfel, with a wild love affair with Oskar Kokoschka thrown in for good measure in between.

Portrait of Fritza Riedler

1906
Osterreichische Galerie, Vienna

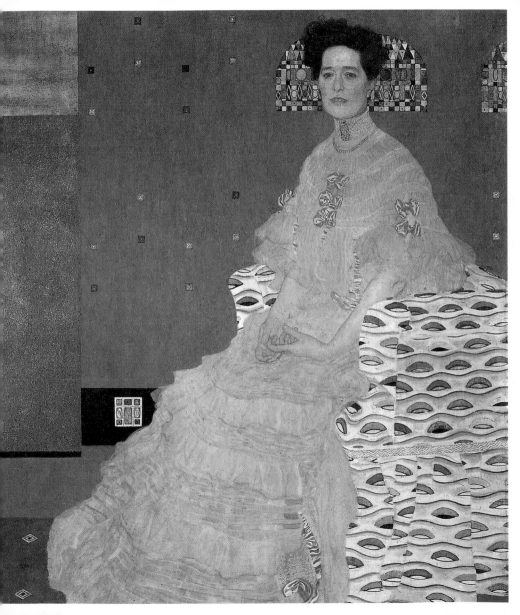

Of her youthful infatuation with Klimt she writes: "He was the most gifted of them all, thirty-five years of age, at the zenith of his powers, beautiful in every sense of the word and already famous. His beauty and my youthful freshness, his genius, my talents, the profound life-melody we shared touched the same chords in us both.

Garden Landscape

1906
oil on canvas, 110 x 110 cm
private collection

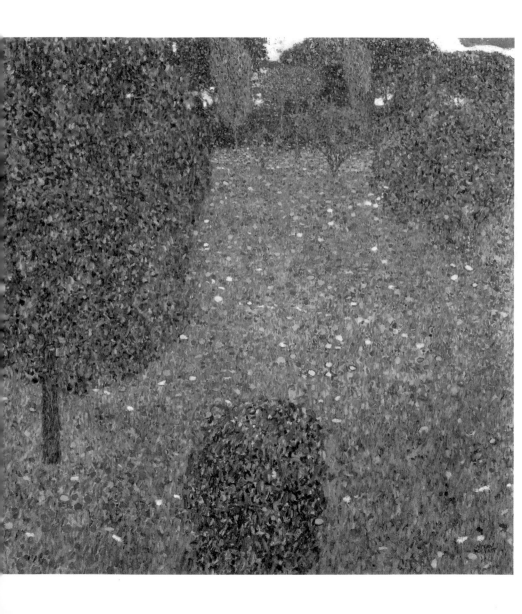

I was ridiculously ignorant of all things passionate – and he felt and found me everywhere … He was bound by a hundred chains: women, children, even sisters who fought over him. But he still followed me..."

The freedom of Klimt's drawings stands in marked contrast to the portraits of society women he produced between 1903 and around 1913.

Pregnant Nude, Standing, Left Profile
Study for "Hope II"

———————————

1907
Black chalk, 49 x 31 cm
Historisches Museum, Vienna

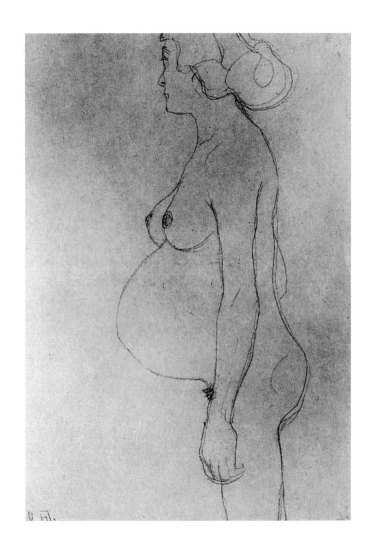

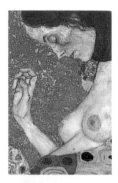

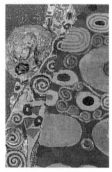

Where the women in his drawings are unconstrained either by clothes or by social conventions, he depicts Fritza Riedler and Adele Bloch-Bauer awash in a sea of pattern and ornament. Their faces stand out, serious and composed, before blocks of pattern or colour strategically placed behind their heads to emphasize their features to the maximum.

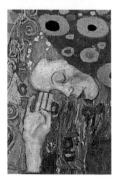

Hope II

1907-1908
oil, gold and platinum on canvas, 110.5 x 110.5 cm
Museum of Modern Art, New York

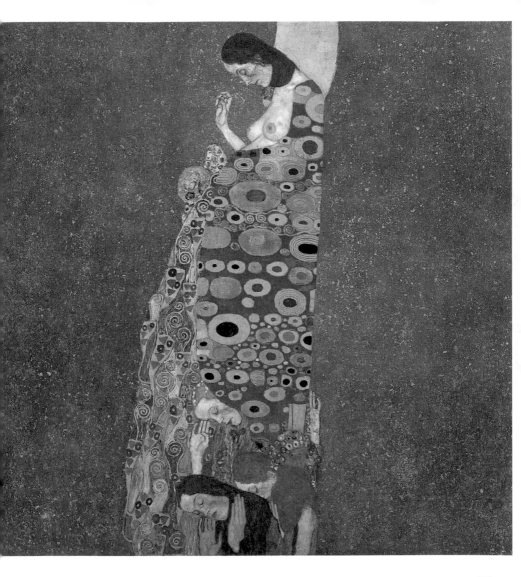

Their bodies are submerged in swathes of textile patterns merging with the background so that the face appears isolated, fragile, alone. The portrait of Margaret Stonborough-Wittgenstein is notable as one of the few which is not dominated by pattern, and is a clear tribute to the work of Whistler, whom Klimt much admired.

Jurisprudence

1907
oil on canvas, 430 x 300 cm
burned in 1945

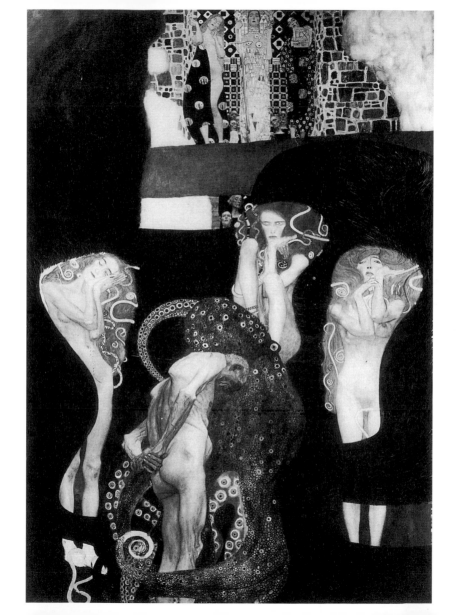

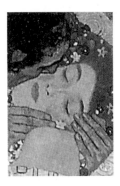

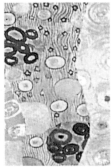

There is also something particularly striking in the gaze and stance of the young Maria Primavesi: she stands, hand on hip, legs apart, the age-old combination of innocence and provocation. These are remarkably delicate portraits.

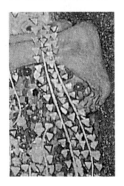

The Kiss

1907-1908
oil on canvas, 180 x 180 cm
Osterreichische Galerie, Vienna

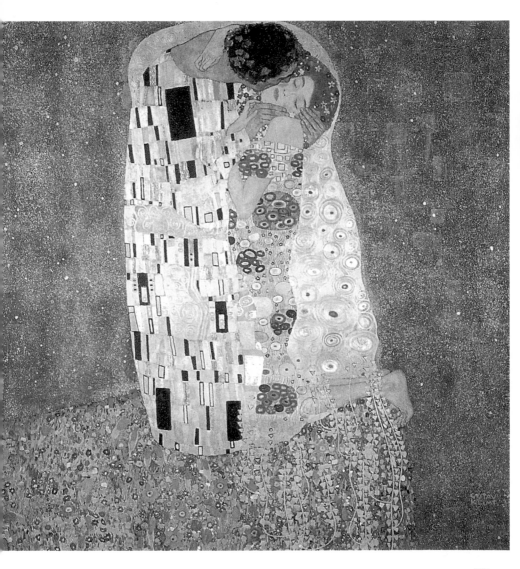

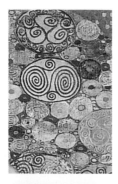

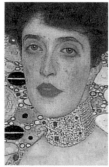

Each face betrays so much about the sitter – a calmness, or an awkwardness, and in Adele Bloch-Bauer's, the only one of these women known also to have been Klimt's lover, it is difficult not to read into her face a desire to pose as luxuriously as Klimt's models did

Portrait of Adele Bloch-Bauer (I)

1907
Osterreichische Galerie, Vienna

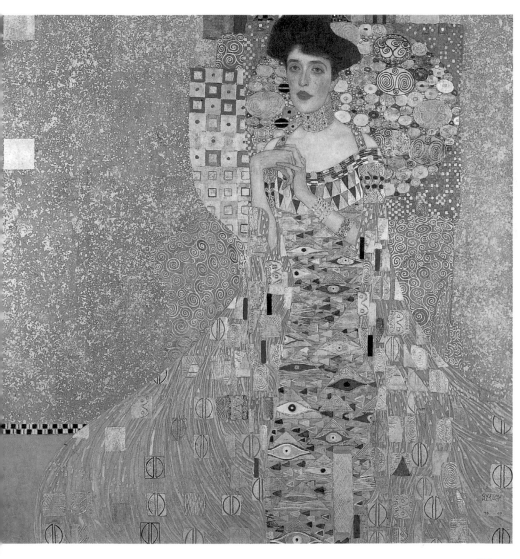

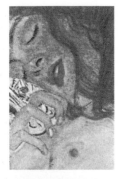

especially in the 1912 portrait, where her open lips, her gaze, and her direct stance suggest a certain sexual readiness in stark contrast to the upright behaviour which would undoubtedly have been expected of her. In Klimt's paintings from the last ten years of his life, pattern, textile and ornament are used to highly erotic effect, emphasizing the nakedness of the body rather than covering it.

Danäe

———

1907-1908

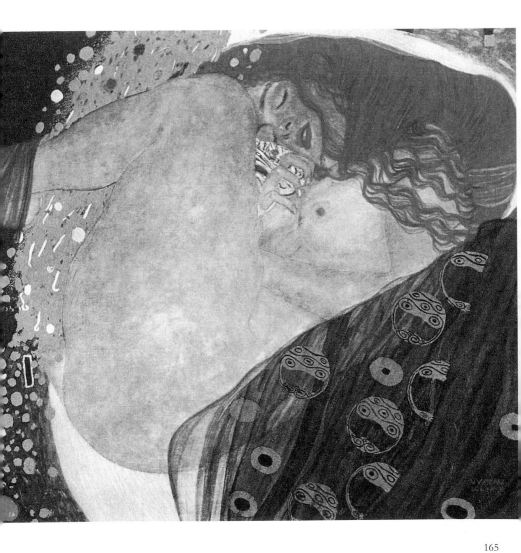

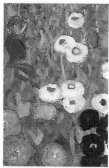

It is as if the women he depicts are imprisoned by the textiles and ornaments, an impression heightened by the artist's heavy use of gold (Klimt had visited Ravenna in 1903, where he had greatly admired the famous Byzantine mosaics).

Garden in Bloom

oil on canvas, 110 x 110 cm
private collection

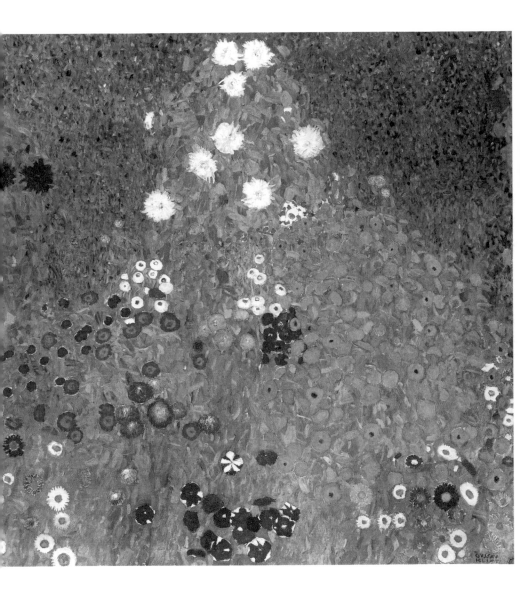

In *Judith* II the clothes seem barely able to contain the energetic nudity of the avenging woman, and in *Bride* textiles are used as a way of isolating shapes and body parts to create a highly erotic effect. Heads and torsos become fragmented, detached from their bodies.

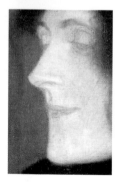

Pallid Figure

1907
oil on canvas, 80 x 40 cm
private collection

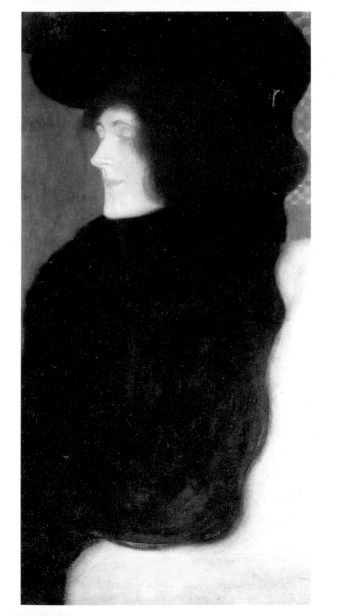

The figure on the far left of the painting almost resembles Man Ray's photograph of a woman's back as a cello, and the figure to the far right of the canvas has her head totally obscured, leaving her breasts exposed while the lower part of her body is covered by a sexy, see-through skirt leaving her open legs and genitals visible.

Kammer Castle on The Attersee I

oil on canvas, 110 x 110 cm
Narodini Gallery, Prague

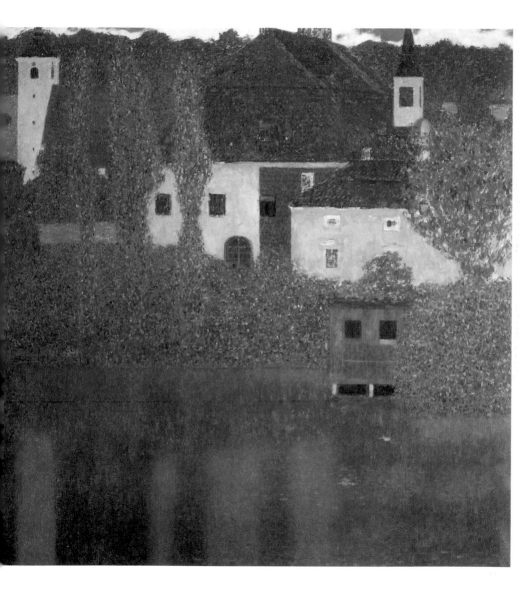

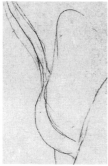

The fact that the provocatively naked body exists beneath these skimpy clothes might even suggest, as some of Klimt's preparatory drawings imply, that in other paintings he actually drew the naked body first, then covered it with textiles and pattern.

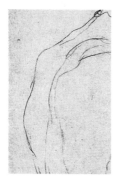

Lying Lovers

—————

1908
black chalk, 35 x 55 cm
Historisches Museum, Vienna

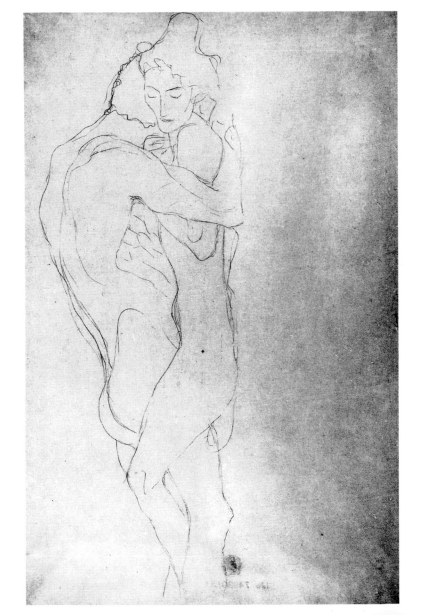

173

This, at least, is the impression one has when looking at paintings such as *Virgin* in which the young girl, depicted asleep, is lying prone on her back in a pose at once innocent and sexually exposed. The clothes look as if they have been thrown on top of her as if to hide her sexual dreams, represented by the mass of semi-naked, presumably more knowing women underneath her.

Woman in Hat with Feather Boa

1909
oil on canvas, 69 x 55.8 cm
private collection

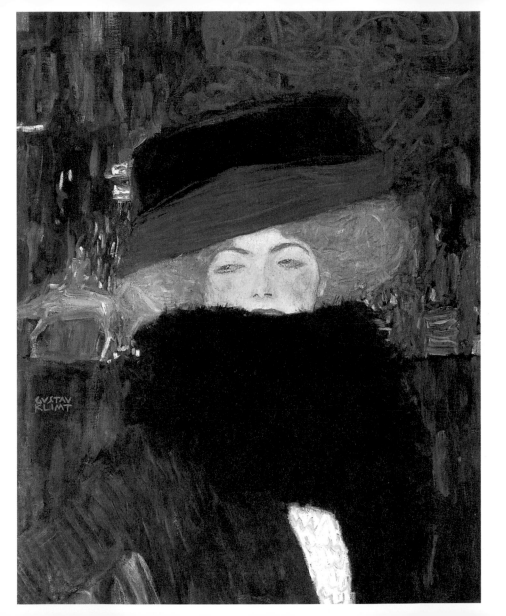

During his entire lifetime, Klimt made only one statement about himself and his art: "I am certain that there is nothing exceptional about me as a person. I am simply a painter who paints every day from morning till night. ... I'm not much good at speaking and writing, especially when I have to discuss myself or my work.

Judith II

———

1909
oil on canvas, 178 x 46 cm
galleria d'Arte Moderna di Ca' Pesaro, Venice

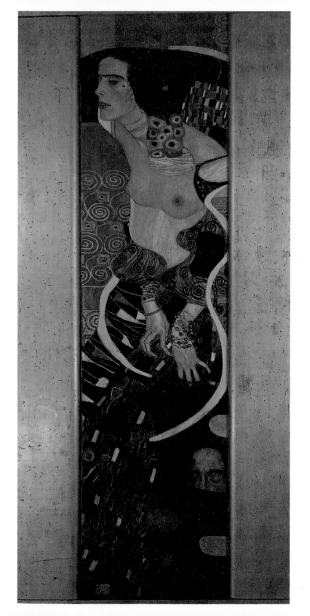

Just the idea of having to write a simple letter fills me with anguish. I am very much afraid that you will have to do without a portrait of me, either painted or in words, but it is no great loss. Whoever seeks to know me better, that is to say as an artist – and that's the only thing worth knowing – should study my paintings and try to glean from them who I am and what I want."

Pond at Kammer Castle
on The Attersee

———————

1909
oil on canvas, 110 x 110 cm
private collection

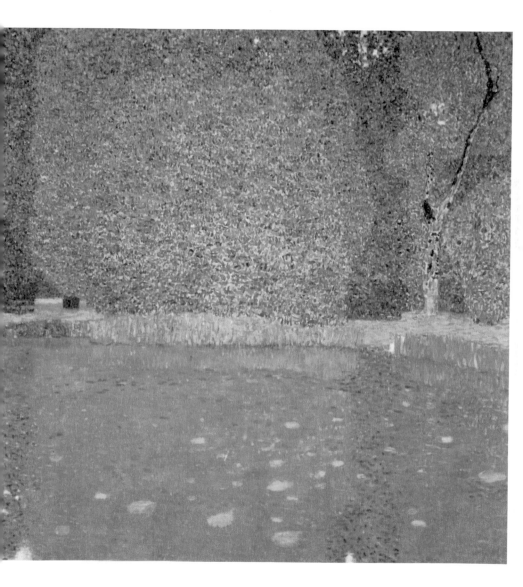

Just how exceptional Gustav Klimt was is perhaps reflected in the fact that he had no predecessors and no real followers.

He admired Rodin and Whistler without slavishly copying them, and was admired in turn by the younger Viennese painters Egon Schiele and Oskar Kokoschka, both of whom were greatly influenced by Klimt.

The Park

1909-1910
oil on canvas, 110,5 x 110,5 cm
The Museum of Modern Art
New York

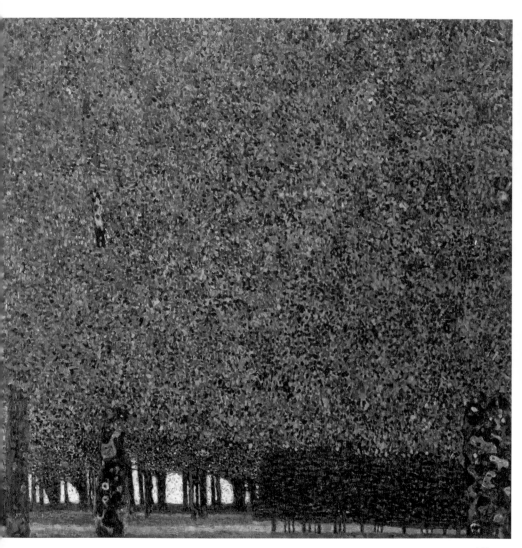

But whereas Klimt belongs to that transitional period at end of the nineteenth century, Schiele and Kokoschka represent the beginnings of that quintessentially early twentieth-century movement, expressionism. Schiele, like Klimt, made many drawings of nudes, but where Klimt's drawings were peaceful, dreamy and delicate, Schiele reflected a tortured and neurotic psyche.

Squatting Woman

1919
graphite, black pencil and lavish, 54.9 x 34.8 cm
Museum der Stadt Wien, Vienna

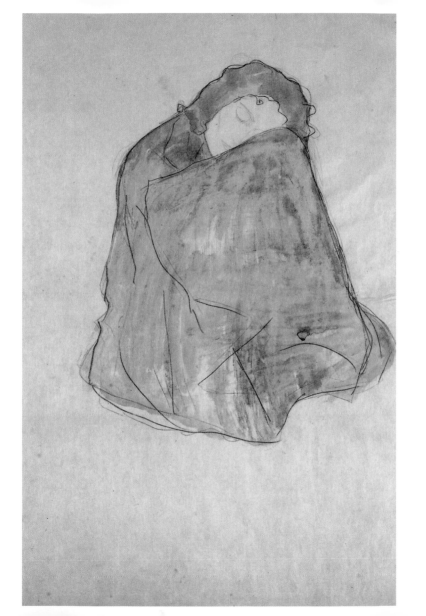

He drew himself endlessly – an emaciated, troubled figure – and his drawings of female nudes manage to render the women simultaneously sexually attractive and repulsive. On January 11, 1918, Klimt suffered a stroke that left him partially paralyzed on one side.

Black Feather's Hat

1910

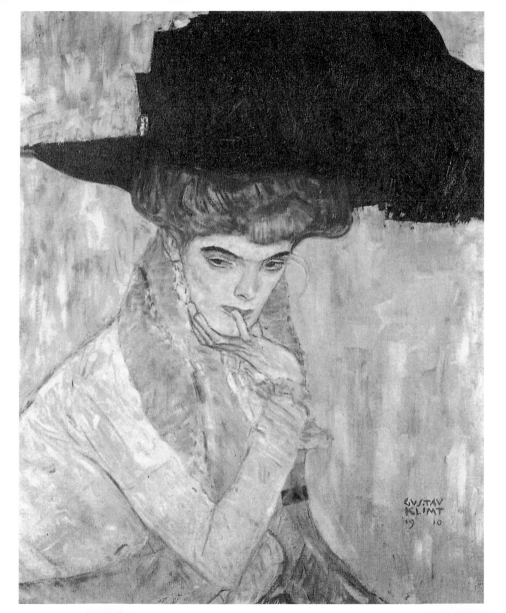

Although he seemed to be recovering, he died a month later. After his death opinion was still divided as to his merits as an artist. Hans Tietze, a friend of Klimt and author of the first monograph on the artist, sums up his importance: "Klimt took Viennese painting ... out of the isolation in which it was languishing and back again into the wide world ...

Garden with Crucifix

1911
Oil on canvas, 110 x 110 cm
Burnt in Immendorf castle in 1945

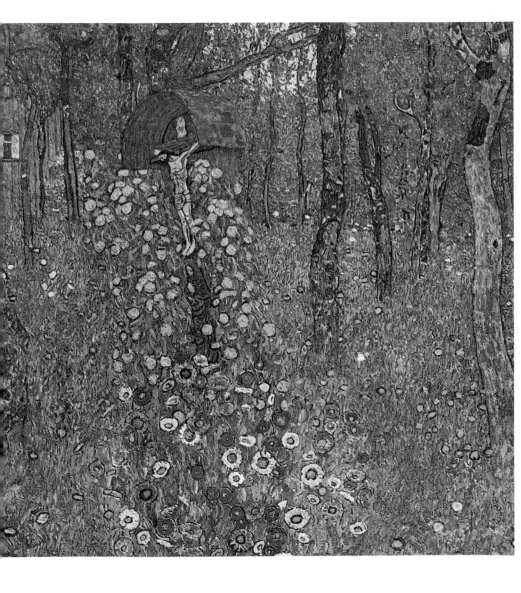

At the turn of the century he, more than anyone else, guaranteed the artistic individuality of Vienna." Klimt, it has been said, could not have existed anywhere but in Vienna. So totally have the images created by him come to represent the Austrian capital at that time that it could indeed be argued that Vienna could not have entered the twentieth century without the bold vision and artistic individuality of Klimt.

Nude Lying Down and Huddling

1912-1913
graphite, red, blue and white pencil
37 x 55,8 cm

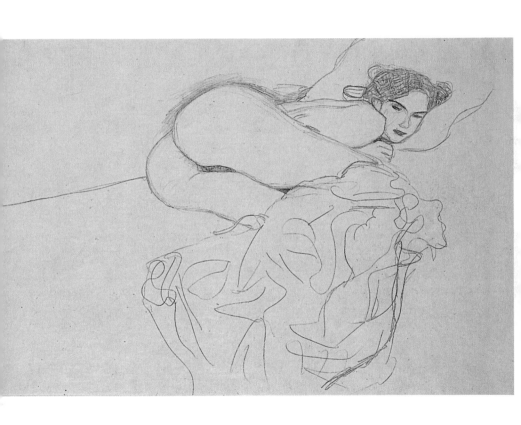

189

Vienna Secession

"To every age it's art, to every art it's freedom
This was the motto, the program and also the
mission for the forty members, all of them
established artists, of the very cosmopolitan
Vienna Secession when the "Association of
Visual Artists" was founded in 1897. Their
motto could also have been: "Art for every-
body and every level of the society."

Portrait
of Adele Bloch-Bauer (II)

1912

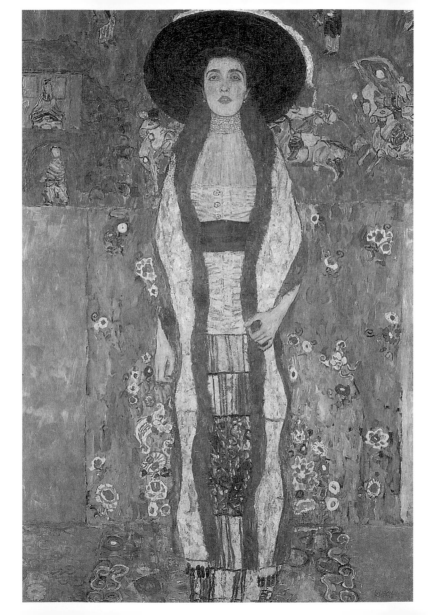

At the fin-de-siècle, the turn-of-the-century, an amazing burst of creativity evolved from Vienna, world shaking in the fine arts. Vienna was obsessed with the aesthetic and the erotic. It was a time of happiness, craziness and dazzling intellectual activity.

Searching for new forms of expression, the Secessionists had a new ideal of beauty and wanted to create a movement without economical, political or financial constraints.

Ria Munk on Her Death Bed

1912
oil on canvas, 50 x 50.5 cm
Dover Street Gallery, London

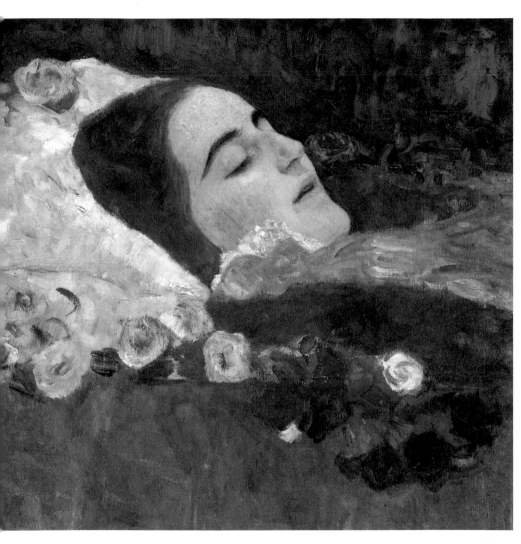

It gave rise to the Secession movement, a Viennese version of Art Nouveau. As the name indicates the Secession (Die Wiener Sezession) was the falling off from the existing artist association and the foundation of a progressive alliance of artists and designers, a creation of a "typically Austrian" Art Nouveau... As previously stated, the group had grown out of the dissatisfaction with the traditional art of the radical members of the Künstlerhausgenossenschaft.

Female Nude Lying Down
(in an Embracing Gesture)

1913. red pencil
37 x 56 cm
Graphische Sammlung Albertina, Vienna

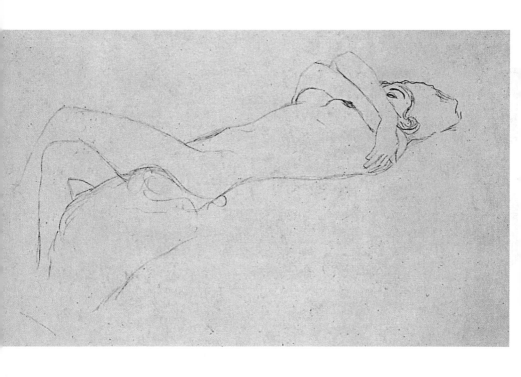

The Secessionists considered the traditional artists association and the prevailing schools of art in Vienna too conservative and academic and contested their lack of innovation. It included four foreign 'corresponding members': Fernand Knopff from Belgium, Max Klinger from Germany, the Swiss Ferdinand Hodler and the Dutch Jan Toorop.

Portrait of Mäda Primavesi

1913
oil on canvas, 149.9 x 110.5 cm
The Metropolitan Museum of Art, New York

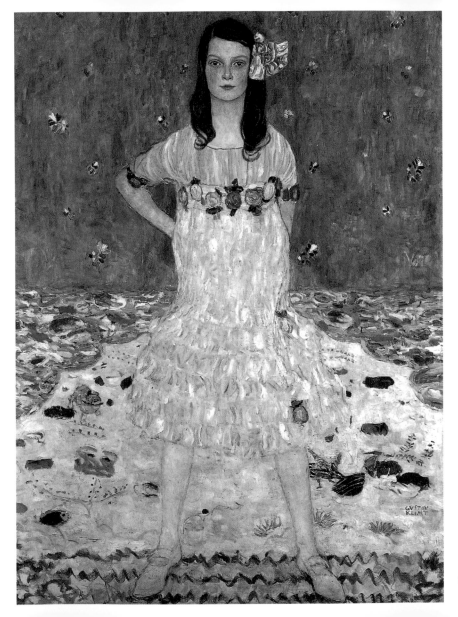

In the resignation letter to Künstler hausgenossenschaft they explain: "As the committee must be aware, a group of artists within the organization has for years been trying to make its artistic views felt. These views culminate in the recognition of the necessity of bringing artistic life in Vienna into

Virgin

———

1913
Oil on canvas, 190 x 200 cm
Narodini Prague

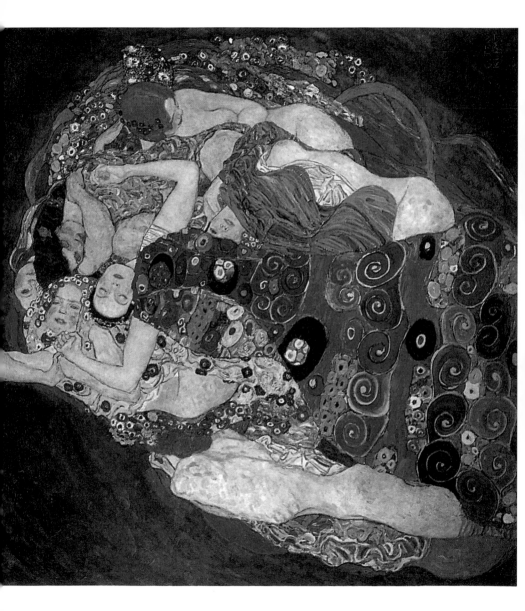

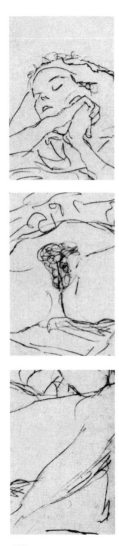

more lively contact with the continuing development of art abroad, and of putting exhibitions on a purely artistic footing, free from any commercial considerations; of thereby awakening in wider circles a purified, modern view of art; and lastly, including a heightened concern for art in official circles.

Semi-nude Sitting and Leaning

1913
pencil, 56 x 37 cm
Historisches Museum, Vienna

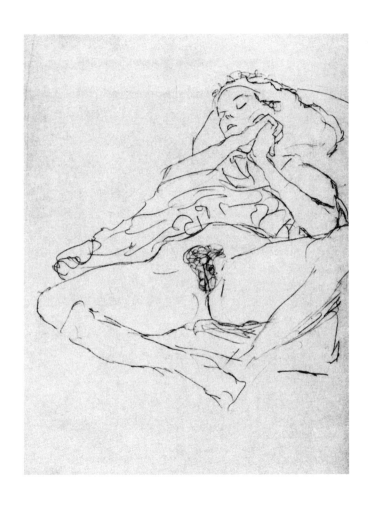

Klimt was one of the founding members of the Vienna Secession and, at the age of thirty-five, he became its first President and remained, together with Josef Hoffmann and Carl Moll responsible for the exhibitions until 1905. Chairing the Secession made him famous and gave him a very influential position towards the monarchy, the government as well as his fellow artists.

Malcesine
on The Lac de Garde

1913
oil on canvas, 110 x 110 cm
burned in 1945 at Immendorf Castle

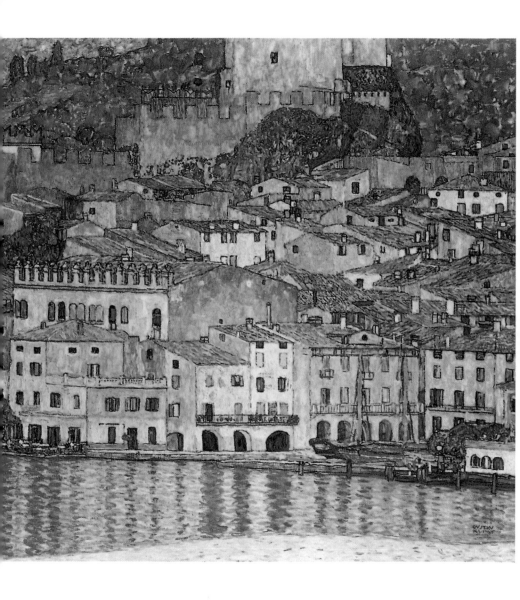

Klimt became rich – and he once said: "Money must be rolling, then it interests me." The Secession succeeded in attracting affluent patrons and financial contributions. They received commissions from theatres, museums and other public institutions.

Portrait of Eugénia Primavesi

1913
oil on canvas, 140 x 84 cm
private collection, USA

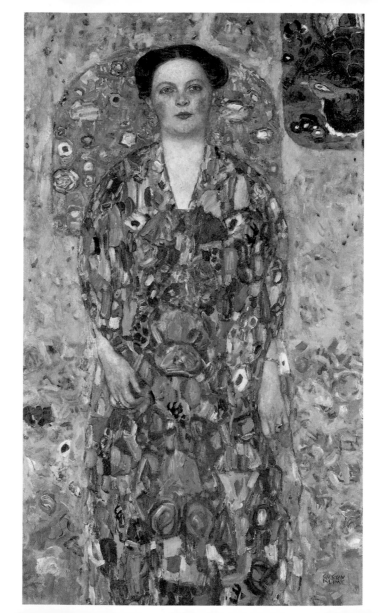

205

The founders of the movement had three aims:
- help young artists to exhibit their work
- bring the best foreign artist to Vienna
- and publish their own magazine
- and to raise Austrian art to the international level.

The Vienna Secession distinguished itself from the Art Nouveau movement by the use of ornamental elements derived from nature such as animals, leaves or vines.

Two Female Nudes Lying Down

1914-1915
pencil, 54 x 35,3 cm
The Metropolitan Museum of Art, New York

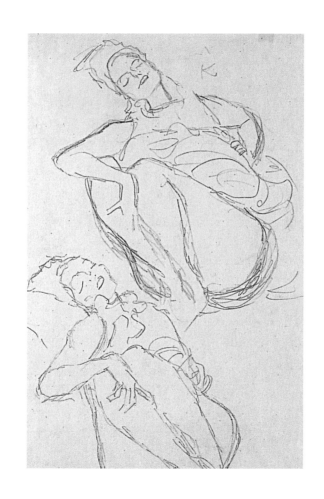

The floral elements frequently contain plastic decorations like snakes and salamanders. This artist's association was not limited to just painters but it was based on the concept of total work of art and included designers, craftsmen, graphic artists and architects.

Semi-nude Lying Down

1914
Blue pencil, 37 x 56 cm
Historisches Museum, Vienna

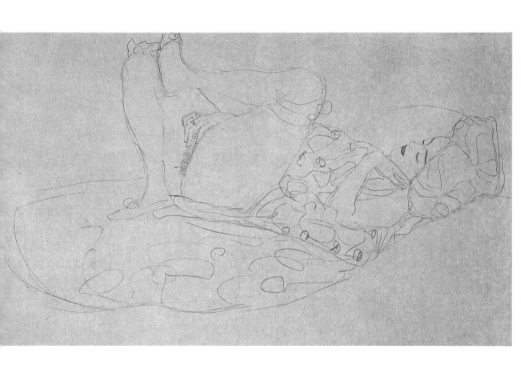

It aimed to transform all facets of human life into one unified work of art. The Secessionist works, at least the earlier ones, were intended to be provocative, and they did not fail to do so. Hevesi said about the architectural style of the Vienna Secession with its unusual oriental elements "the ancient golden backgrounds of the Middle Ages"

Portrait
of Elisabeth Bachofen-Echt

1914
private collection

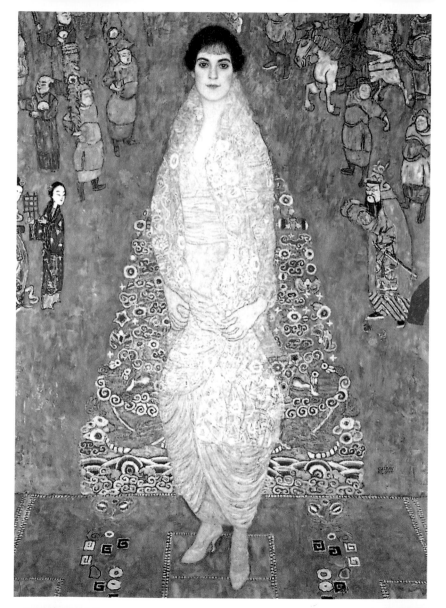

In April 1898 the first exhibition of the association took place in their own building in Joseph Maria Olbrich's Vienna Secession Building, given to the artists as a gift by the City Administration. Joseph Maria Olbrich, a young architect and winner of the 'Prix de Rome', worked in the studio of Otto Wagner.

Path of Garden and Hens

1916
oil on canvas, 110 x 110 cm
burned in 1945 at Immendorf Castle

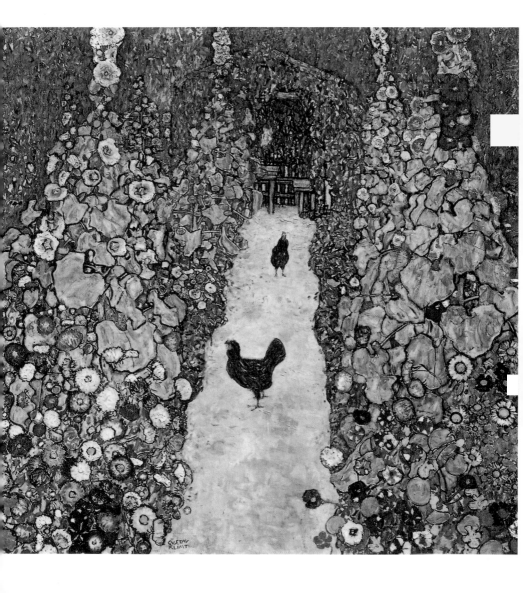

He was commissioned with the execution of the exhibition hall. The money needed to achieve it, was partly given by sponsors, the most generous being the philosopher Ludwig Wittgenstein's father. Olbricht wrote about the building he was going to construct: "It should be be walls, white and bright, sacred and pure."

Female Nude Wearing Lingerie

1916-1917
graphite, 37 x 56,4 cm, Vienne

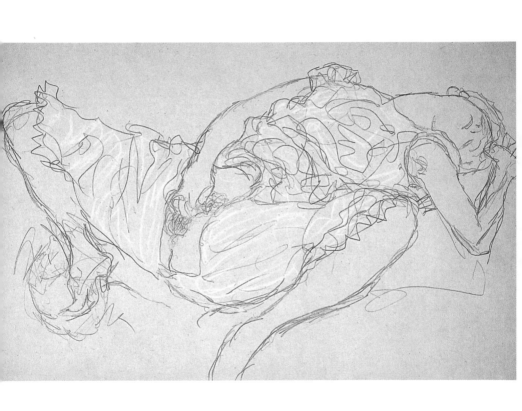

The population of Vienna ridiculed the building, calling it "The temple of tree frogs" or "The tomb of Mahdi", or even worse than that "The crematorium" or "The mausoleum" and the dome was commonly designated as "The cabbage head." The first Secession exhibition took place from the 26th of March to the 15th of June and included Gustav Klinger's Pallas

Woman Seated with Open Thighs

1916
Graphite, white highlights, red pencil
57 x 38 cm, Private Collection

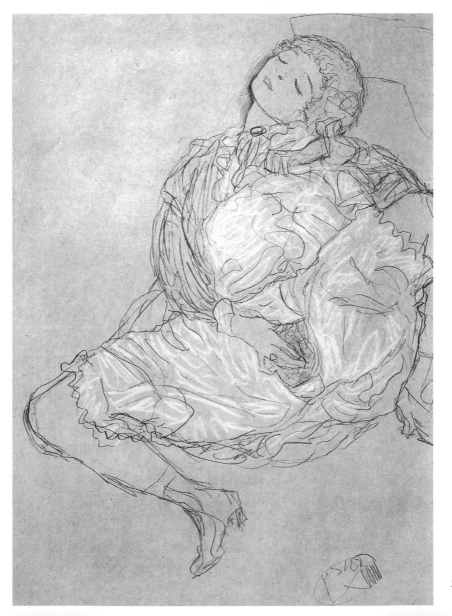

217

Athena, applied arts with wallpaper, bookbinding, works in gold, silver and leather, furniture and joinery, works by the Swede Anders Zorn, works by the Belgian artist Fernand Knopff art glass works, such as bowls, gobelets, tumblers, vases and jars with geometrical patterns in overlaid and cut glass or painted and gilt decoration.

Girlfriends (detail)

1916-1917

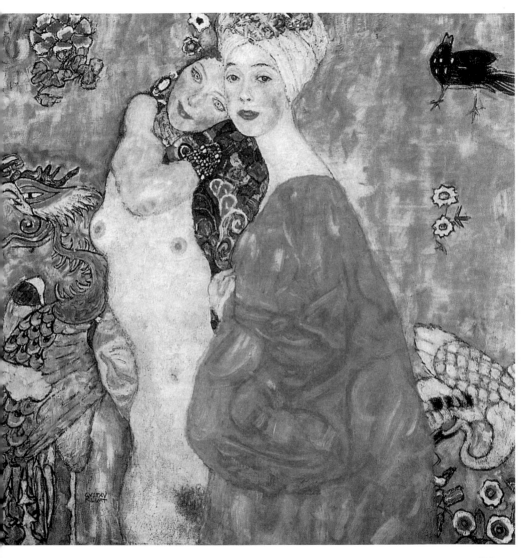

Joseph Hoffmann, who played a major part in the shaping of the aesthetic perception and understanding of the aesthetics of the 20th century, was an important contributor to the success of the first exhibition.

In the preface of the catalogue of the second exhibition, the visitor could read: "May this house become a home for the serious artist as for the true art lover.

Dancer

———

1916-1918
oil on canvas, 180 x 90 cm
Private Collection

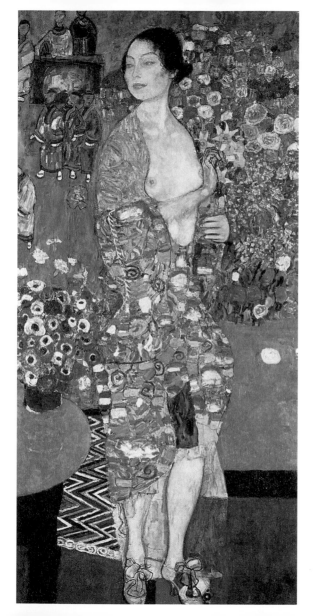

May they both, creating and enjoying, seeking and finding, be here united in this temple in sacred service, so the Hervesi's words, which our building bears on its brow, may in truth come to pass: To every age its art, to art its freedom."

The poster for this exhibition was created by Klimt and depicts a naked Theseus in battle with the Minotaur which Klimt was obliged to alter.

Life and Death

1916
oil on canvas, 178 x 198 cm
Collection Leopold, Vienna

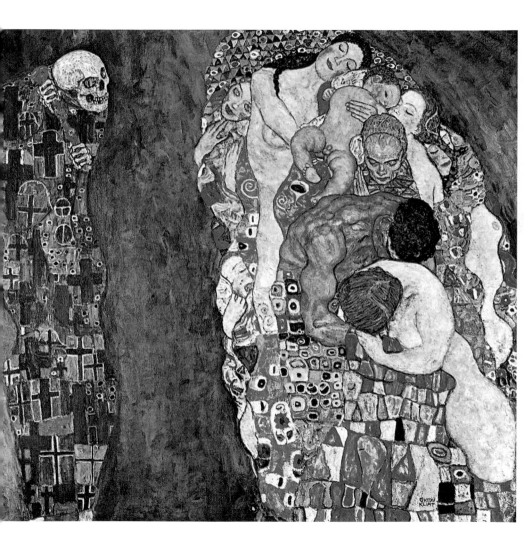

223

It proved to be a tremendous success with over fifty-six thousand visitors and sales amounting to 85 000 guilden and was almost instantly established as a force to be counted with. Even the Austrian Emperor Franz Josef was among its renowned visitors and Klimt received the Gold Service Cross from the Emperor. The eighth issue of Ver Sacrum announced the sale of no less than 218 works.

Houses at Unterach
on The Attersee

1916
oil on canvas, 110 x 110 cm
Osterreichische Galerie, Vienna

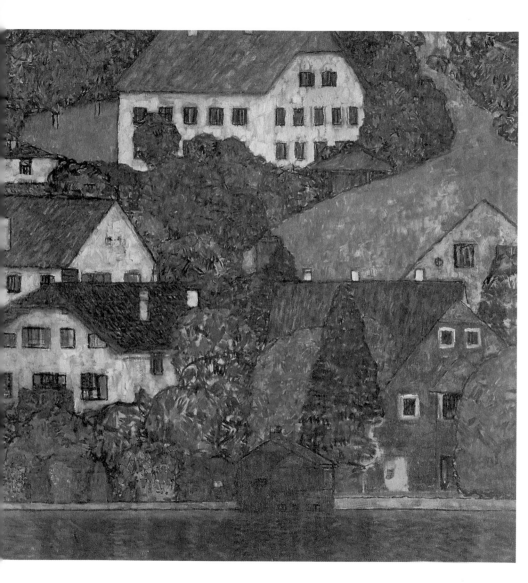

In 1900, the 6th exhibition was devoted to Japanese art and paid tribute to the Japonisme as an artistic movement born out of the influence of Japanese art in Europe. It was a time of awakening in all the arts. In 1902 he created the "The Kiss" for the Secession and "the Beethoven Frieze", depicting man's search of happiness, as part of Klinger's sculpture "Beethoven". They were among the symbols of Vienna Secession.

Garden and Summit of a Hill

1916
oil on canvas, 110 x 110 cm
Kunsthaus Zug, Switzerland

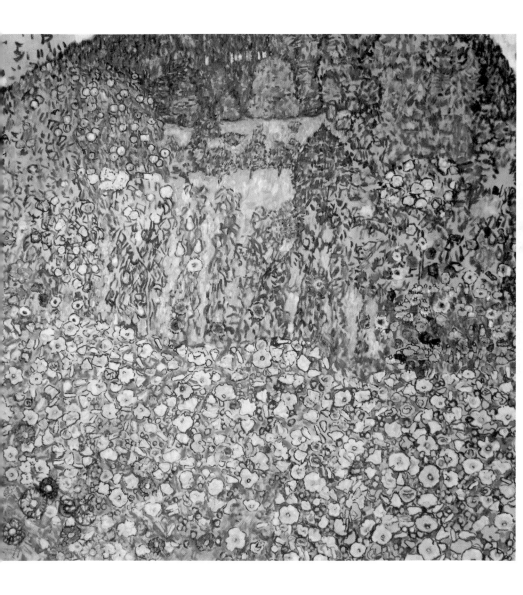

The artistical sources and inspiration were drawn from photography, classical Greek-, Byzantine-, Egyptian and medieval art, especially the late medieval paintings and woodcuts of Albrecht Dürer. In 1904, the Belgian millionaire Adolphe Stoclet commissioned for the dining room of his palace, known as 'The Palais Stoclet', a huge mosaic frieze from Klimt known today as the Stoclet-frieze.

The Church at Unterach
on The Attersee

—————————

1916
oil on canvas, 110 x 110 cm
private collection, Graz

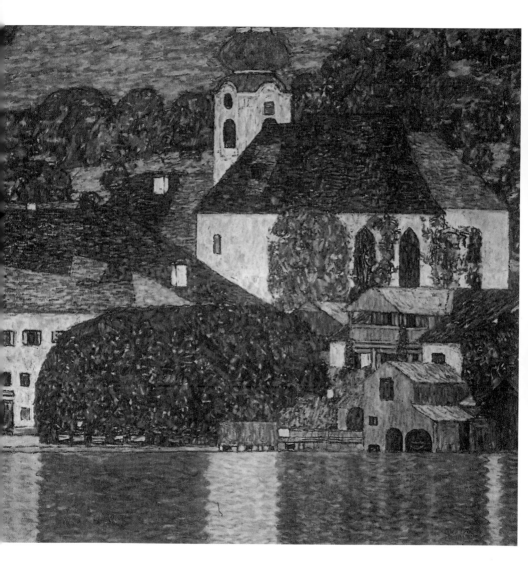

Klimt seceded from the Vienna Secession in 1905 after ongoing conflicts, quarrels and disputes with the other members of the group which finally proved irreconcilable. A rift had grown between two groups: the 'Klimtgruppe' (the Klimt supporters) and the 'Nur Maler' (the pure painters).

Portrait
of Friederike Maria Beer

1916
Art museum of Tel Aviv

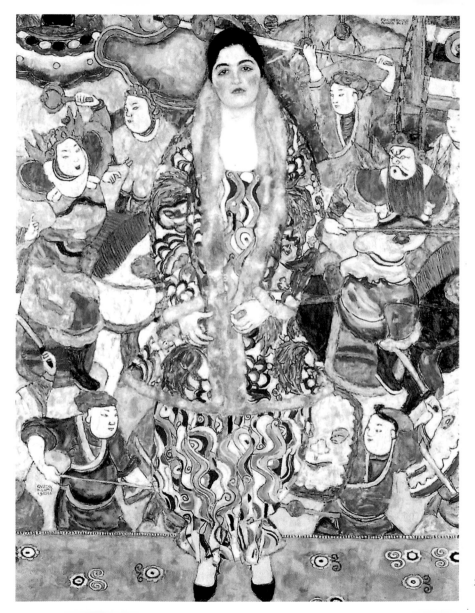

Whereas the 'Klimtgruppe' wanted to include applied arts, architecture and design as opposed to the 'Nur Maler' who wanted to promote easel painting only. Klimt had been the driving force and one of the strongest protagonists of the association. The Secession ideal, the harmony of the arts and the redemption of the world through art, had proven to be an unachievable utopia.

Emilie Flöge

Photo

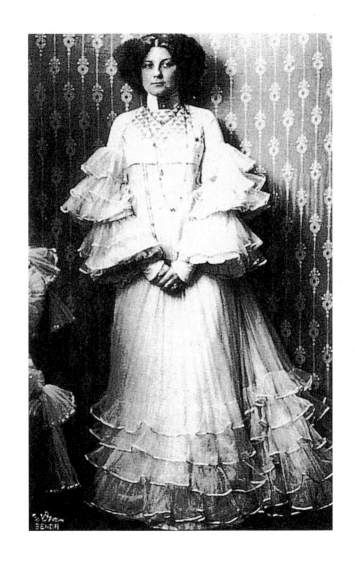

233

"Ver Sacrum"

"Ver Sacrum", (The Rite of Spring or Sacred Spring), the mouthpiece of the Vienna Secession, was the name of the major magazine of the Vienna Secession, created to spread the Secession's new ideas. The origin of the the name can most probably be found in a poem by Ludwig Uhland "Der Weihefrühling" (Sacred Spring).

Leda

———

1917 (destroyed)

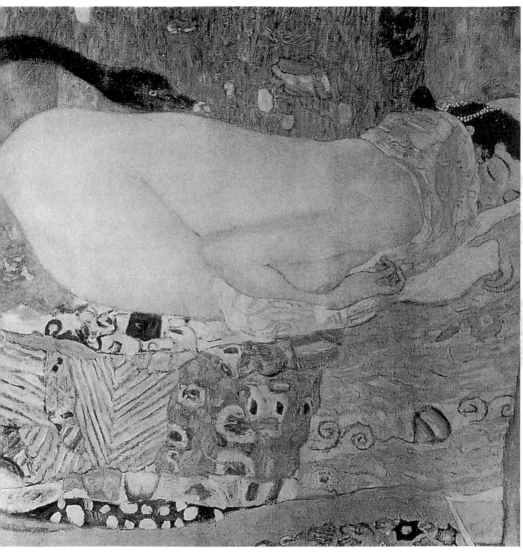

Some art historians, however, believe that the name goes back to an ancient Roman rite born in spring, dedicated to divinities and destined to found a new community.

It was published between 1898 and 1903, in a limited edition of only three hundred copies of each edition, it was published monthly for the first two years and after that only every second month.

Bride (Unfinished)

1917-1918
oil on canvas, 166 x 190 cm
Private Collection

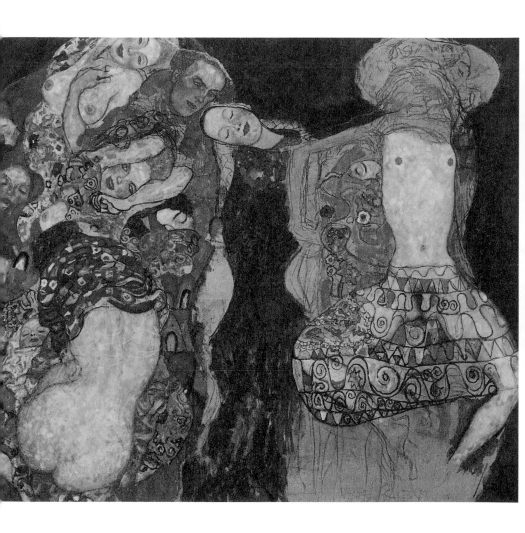

Klimt was a frequent contributor to Ver Sacrum. The publication was highly respected from an artistic and literary standpoint and had great influence on Austrian as well as foreign artists. Hermann Bahr formulated the most important principle of it : "We want an art that is not subservient to outside influences, but at the same time does not fear or hate them."

Baby (Detail)

1917-1918
oil on canvas, 110 x 110 cm
National Gallery or Art, Washington

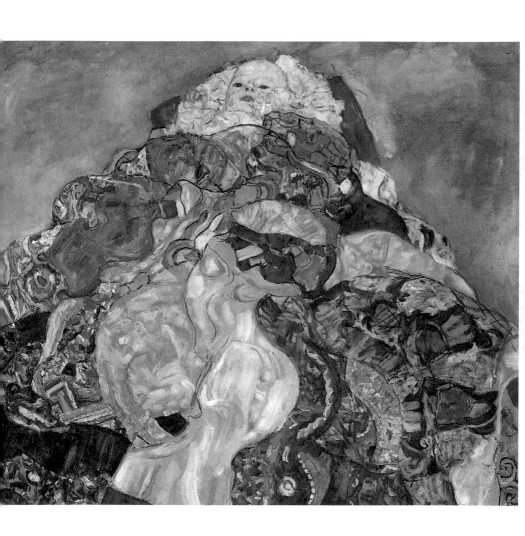

239

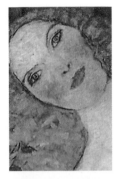

Between 1878 and 1903 about seventy issues were published, each of them had an evident didactic role and was frequently devoted to a special theme. A whole special issue was, for example consecrated to Jan Toorop, whose symbolic pictorial language influenced Klimt.

Adam and Eve (Unfinished)

1917-1918
oil on canvas, 173 x 60 cm
Osterreichische Galerie, Vienna

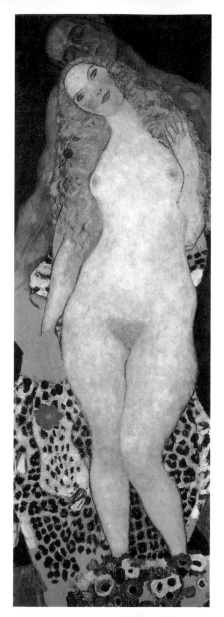

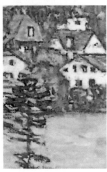

Another entire issue was devoted to Knopff reproductions and the periodical of November 1899 embraced an essay on Rysselberghe's work by the Belgian poet Emile Verhaeren. Ver Sacrum promoted the idea of 'total art' (Gesamtkustwerk) designing all arts to form a synthesis and that could be shared universally by the rich and the poor, the mighty and the powerless.

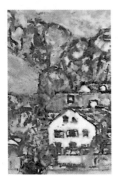

Forest in a Slope Mountain
at Unterach on The Attersee

1917
oil on canvas, 110 x 110 cm
private collection

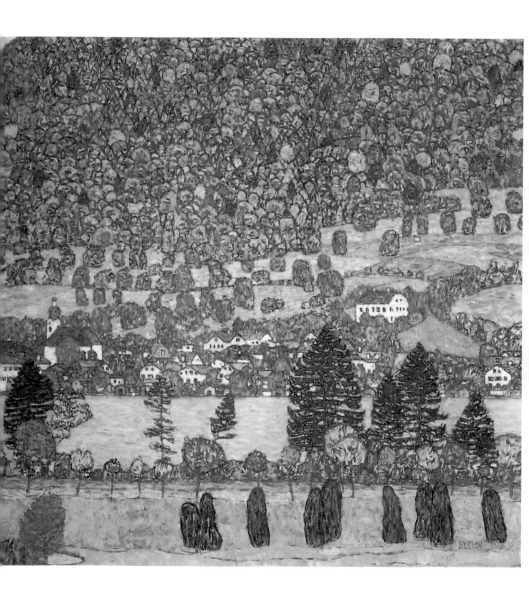

The contents consisted in a mix of articles on art theory, practical examples and often contained original printed graphs. It was published about the same time as another major magazine called "Die Jugend" (The Youth) on the other side of the Alps, in Munich. It was at the origin and it gave the name to the movement "The Jugendstil".

Portrait of Johanna Staude

1917
oil on canvas, 70 x 50 cm
Osterreichische Galerie, Vienna

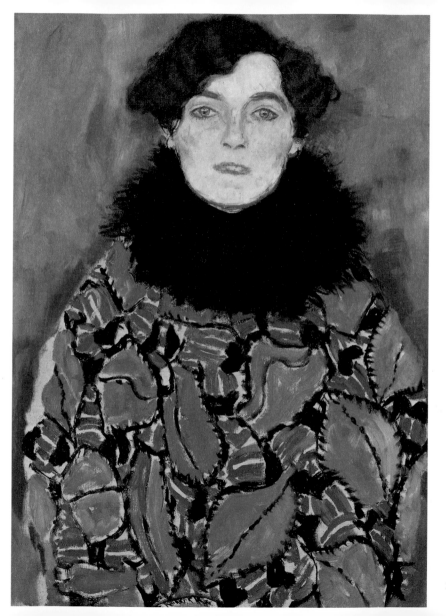

In France, at that time, another movement was born at the turn of the century, called "Art Nouveau" – The New Art, showing the break with classicism and the search for new ways of expression. The same tendency could be found in Italy – called "Stile Liberty" and in Spain under the name of "Modernista". It was an International revolt against the traditional academic art.

Ver Sacrum ceased to exist in 1905 due to of a lack of subscribers.

Portrait of a Woman

1917-1918
oil on canvas, 67 x 56 cm
Neue Galerie der Stadt Linz, Autriche

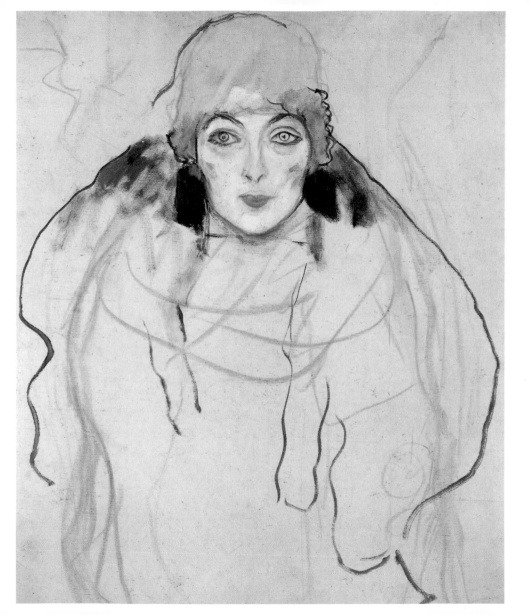

Index